IMAGES
of America

CERULEAN SPRINGS
and the SPRINGS *of*
WESTERN KENTUCKY

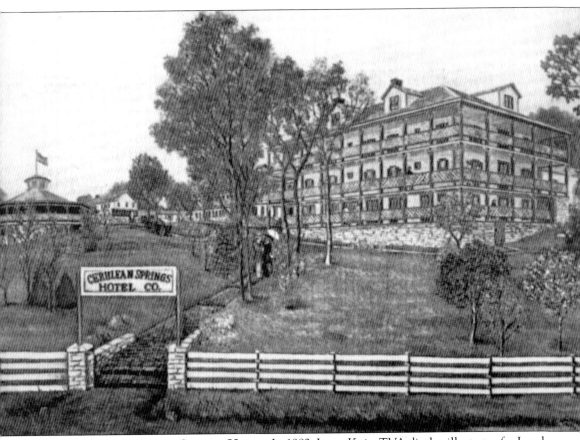

PAINTING OF CERULEAN SPRINGS HOTEL. In 1982, Larry Knie, TVA display illustrator for Land Between the Lakes, rendered this painting of the Cerulean Springs Hotel. Prints were produced and sold, but the original was destroyed in a fire.

ON THE COVER: The springhouse at Cerulean Springs Hotel is seen here in 1909 as visitors gather to socialize and enjoy the springwater.

IMAGES
of America

CERULEAN SPRINGS
and the SPRINGS *of*
WESTERN KENTUCKY

William T. Turner
and LaDonna Dixon Anderson

ARCADIA
PUBLISHING

Published by Arcadia Publishing
Charleston SC, Chicago IL, Portsmouth NH, San Francisco CA

Printed in the United States of America

Library of Congress Catalog Card Number: 2006931756

For all general information contact Arcadia Publishing at:
Telephone 843-853-2070
Fax 843-853-0044
E-mail sales@arcadiapublishing.com
For customer service and orders:
Toll-Free 1-888-313-2665

Visit us on the Internet at www.arcadiapublishing.com

In Memory of My Father
W. E. "Gene" Turner
1900–1965
Native of Cerulean Springs

In Memory of My Grandparents
M. Delbert Dixon and Elva McCoy Dixon
1907–1986 and 1909–1999

In Honor of My Father
Donald H. Dixon

CONTENTS

ACKNOWLEDGMENTS

The authors would like to thank the following for their assistance and inspiration in the preparation of this book: Irl Ames, Don Atwood, Wallace M. Blakeley, Janet Bravard, Anna Gardner Bryant, Lee and Annalu Cameron, Cave Spring Baptist Church, D. D. Cayce III, Cerulean Missionary Baptist Church, Cerulean United Methodist Church, Cerulean Volunteer Fire Department, Christian County Historical Society, Mark Clark, Jerry Cortner, John DeBlois, Jed and Scott Dillingham, Dorothy Gardner Doss, Tommie Warren Frey, Claude Holeman, Charles R. Jackson, Gaylon King, Larry Knie, Pat Lee, J. Brooks Major, Jeanette Mitchell McCain, Dorris Burgess McGill, Denny Mize, Pennyrile Area Development District, Pennyroyal Area Museum, Shalmon Radford, Radio Station WKDZ, Dabney and Betty Rascoe, Leon Roberts, Trigg County Historical Society, Sara Turner Shemwell, Tom Sholar, Lucy Belle Eckles Shook, Donna Stone, LaVena Turner, Mary Stewart Turner, Brenda Underdown, Lysbeth Wallace, Joanna Fort Watson, Alan Watts, Rip Wheeler, Richard V. Williamson, Leo Y. Wilson, Judy Winn, and Joe Woosley.

Sincere thanks are also expressed to the staff of Arcadia Publishing, especially to Kendra Allen, editor; Lauren Bobier, publisher; Nancy Collins, publicist; and Marissa Foster, southern sales manager.

Special thanks are extended to Ruby Blakeley Carter, Chris Gilkey, Billyfrank Morrison, and Ben S. Wood III. We would like to acknowledge with sincere appreciation the late state senator Tom Turner, great-uncle of the coauthor, William T. Turner, who collected and saved a large number of the Cerulean Springs Hotel pictures and to Tom Turner's late sister-in-law, Anna Rawls Turner, for having graciously passed the collection on to the coauthor.

Sincere, heartfelt gratitude is expressed to my coauthor, LaDonna Dixon Anderson, for her patience, knowledge, and support in the completion of this project.

Anderson would like to thank her husband, Andy, for his love and support in this project. She also would like to thank her children, A. J., Rachel, and Katherine for making every day an adventure. Lastly, her deepest appreciation and love goes to the coauthor William T. Turner, who has inspired in her a better understanding of history, a love for community, and a deep-rooted desire for learning. She would also like to thank him for the selfless hours he has contributed to this project and others, for without him, much of Trigg and Christian Counties' history would be lost.

INTRODUCTION

Humanity has used mineral waters for their curative power much longer than recorded history. The ancient Greeks, the Roman world, and promoters across Europe and England established mineral baths around which resorts were developed. The mineral resorts of Western Kentucky offered guests the reflective experience of their curative waters, along with fine accommodations and amusements. These social customs developed in ancient Europe, spread across pioneer America, and remained popular in the lower Ohio River Valley through the antebellum era.

Cerulean Springs and the Springs of Western Kentucky is an attempt to relate the history of some health resorts in parts of Western Kentucky bounded by Breckinridge, Grayson, Edmonson, Warren, and Allen Counties on the east; the Ohio River on the north; Kentucky Lake on the west; and the Tennessee line on the south. Within this area of 24 counties, mineral springs are known to have been located in at least 20. The springs in nine of these counties are represented in history and photographs. The commonwealth of Kentucky had at least 125 watering places in the mid-19th century, and 100 of these had operating health resorts.

From 1820 to 1960, Western Kentucky witnessed the establishment of about a dozen mineral-spring health resorts, the gradual decline thereof, and the end of a great economic and social enterprise. Their story is deeply carved in the culture and legend of the area. Early settlers quickly learned about the medicinal qualities of these springs and came to drink and bathe in them. Public entertainment and lodging were offered in a limited fashion at the village taverns and cabins built around the springs. Substantial frame, stone, and brick hotels replaced these cabins in the 1840s. With the addition of this lodging, the emerging well-to-do class had more opportunity to socialize with their equals from both in and out of state.

Physicians recommended the internal and external use of these waters. They promoted the waters as especially beneficial for diseases of the stomach, liver, and kidneys, as well as for skin diseases, consumption, asthma, rheumatism, bronchitis, dropsy, and gout. During the summer months of 1833, 1849, and 1854, Asiatic cholera swept up the Mississippi Valley, claiming the lives of many Kentuckians.

To escape cholera, other fever-related diseases, and the hot weather of the Deep South, the Southern planters brought their wives, children, and servants north to spend the summer season.

The 1850s brought another aspect of life to the mineral spring resorts. Congenial company was created by good food, well-stocked bars, long dinner tables, and veranda conversations that established new friendships. Hotel guests enjoyed such activities as cards, billiards, fiddling, bowling, crochet, fishing, horse jockeying, and ballroom dancing that concluded with "Good Night Ladies."

Mineral spring resorts faded slowly. The annual appearance of circuses, minstrels, chautauquas, and county fairs, as well as excursions to Mammoth Cave and Natural Bridge and railroad tours to Niagara Falls, Old Point Comfort, and Atlantic City drew people's attention to historical attractions and the bright lights of big cities. With the coming of the automobile, good roads, and county-seat amusements—especially the picture show—the fate of the old resort hotels was sealed.

Charles B. Thorne, in his article "The Watering Spas of Middle Tennessee," described the conclusion of the mineral-spring resort era, "The ever prevalent fires would take their toll and the Great Depression would close other hotels, but the ultimate assassins were the automobile and the modern highway."

For seven score years, these mineral resorts—with all their romance, successes, and even hardships—created for us a most colorful chapter in history. The glory and grandeur of the old mineral spring hotels is gone forever. However, they will forever remain a cherished memory.

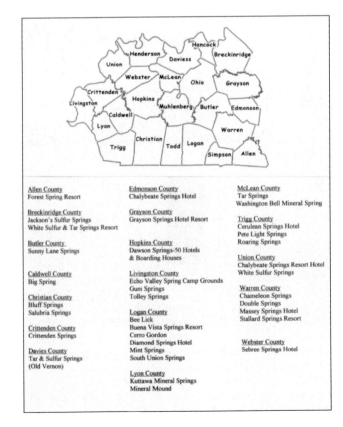

Allen County
Forest Spring Resort

Breckinridge County
Jackson's Sulfur Springs
White Sulfur & Tar Springs Resort

Butler County
Sunny Lane Springs

Caldwell County
Big Spring

Christian County
Bluff Springs
Salubria Springs

Crittenden County
Crittenden Springs

Davies County
Tar & Sulfur Springs
(Old Vernon)

Edmonson County
Chalybeate Springs Hotel

Grayson County
Grayson Springs Hotel Resort

Hopkins County
Dawson Springs-50 Hotels
& Boarding Houses

Livingston County
Echo Valley Spring Camp Grounds
Gum Springs
Tolley Springs

Logan County
Bee Lick
Buena Vista Springs Resort
Cerro Gordon
Diamond Springs Hotel
Mint Springs
South Union Springs

Lyon County
Kuttawa Mineral Springs
Mineral Mound

McLean County
Tar Springs
Washington Bell Mineral Spring

Trigg County
Cerulean Springs Hotel
Pete Light Springs
Roaring Springs

Union County
Chalybeate Springs Resort Hotel
White Sulfur Springs

Warren County
Chameleon Springs
Double Springs
Massey Springs Hotel
Stallard Springs Resort

Webster County
Sebree Springs Hotel

SPRINGS OF WESTERN KENTUCKY. This map lists the locations of the springs of Western Kentucky and their associated hotels.

One

CERULEAN SPRINGS
HOTEL

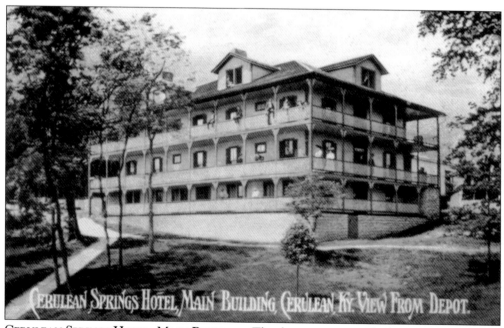

CERULEAN SPRINGS HOTEL, MAIN BUILDING. The three-story annex built in 1901 is portrayed in this color-tinted card made in Germany and distributed by exclusive importers C. E. Wheelock and Company, Peoria, Illinois. This frame weatherboard addition, which provided 50 guest rooms—each equipped with a china washbowl, pitcher, and chamber pot—also featured 750 feet of gallery walkways. The building was painted white and trimmed in green with a wood-shingle roof.

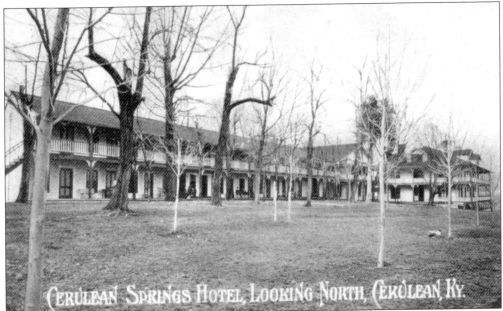

CERULEAN SPRINGS HOTEL, LOOKING NORTH. This Wheelock card, mailed from the hotel in 1909, is the only known image of the entire hotel structure. The northern view shows the old portion, built in 1870, replacing the original hotel. This section featured 22 guest rooms, 11 on each floor, with the upper level accessed by a covered porch. The annex can be seen on the far right.

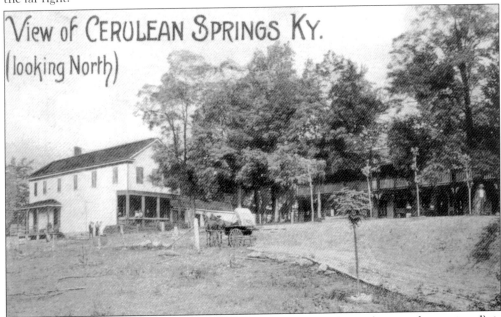

CERULEAN SPRINGS HOTEL STORE. This postcard, looking southwest (not north, as printed), is a Wheelock card. It shows the hotel store, which was built about 1882 and torn down about 1936. The store included a stock of groceries, a post office, a saloon on the first floor, and a gambling hall (poker flats) on the second floor. The old section of the hotel can be seen through the trees on the right.

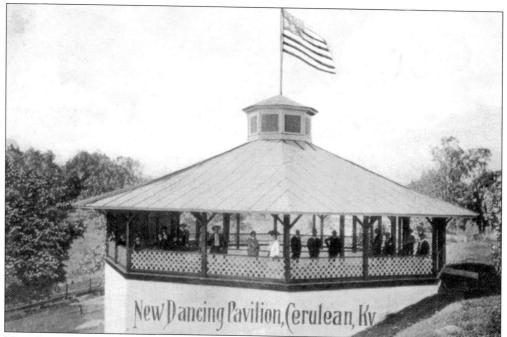

NEW DANCING PAVILION. The fourth in a series of Wheelock cards was mailed to Evansville, Indiana, in August 1911. After years of having guests dance in the hotel ballroom, the owners built a new outdoor octagonal-frame pavilion in 1905. Two years later, a skating rink was erected around the pavilion. This landmark fell into disuse after the hotel burned and the structure rotted in the 1930s.

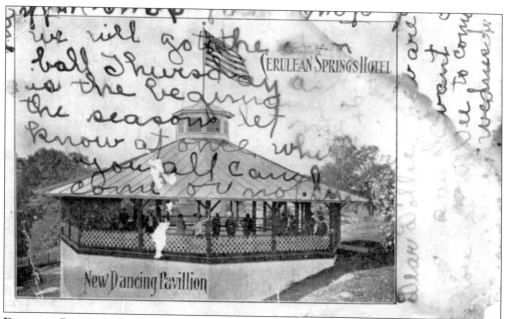

DANCING PAVILION. Poor treatment has left this card in bad condition. This black-and-white illustration, despite having a slightly different inscription, is taken from the same photograph as the previous postcard. It was mailed to Miss Dollie Lander in Eddyville, Kentucky, in June 1907.

In Clover at Cerulean Springs.

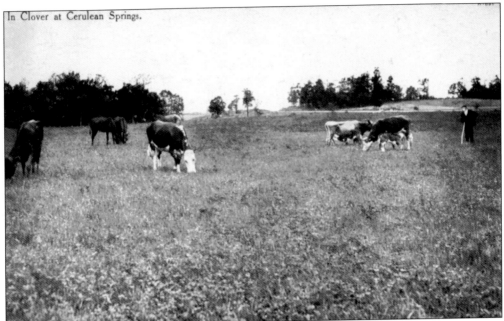

IN CLOVER AT CERULEAN SPRINGS. Mrs. H. S. McElroy in Lebanon, Kentucky, received this rare postcard from Cerulean Springs in June 1911. This summer view gives an impression of a day on the hotel farm. The farm, which varied from 130 to 300 acres through the 108-year history of the Cerulean Springs Hotel, provided fresh vegetables, milk, fruit, beef, hog meat, and mutton for the hotel dining-room table.

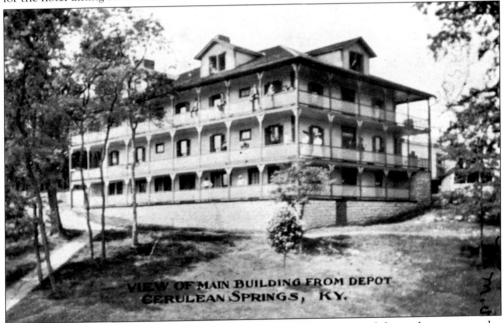

VIEW OF MAIN BUILDING FROM DEPOT. This black-and-white postcard shows the most popular view of the hotel annex. It was mailed to Hopkinsville, Kentucky, on June 4, 1907. Hotel guests arriving at the Cerulean Springs depot caught their first glimpse of the famous spa from this angle. The card features a 1¢ Benjamin Franklin postage stamp.

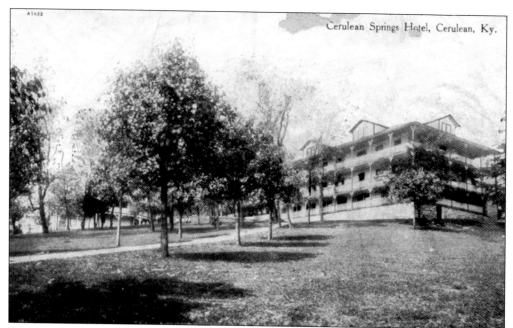

CERULEAN SPRINGS HOTEL. Another view from the railroad station catches a wider glimpse of the hotel grounds. The annex can be seen on the right, and the base of the dancing pavilion is barely visible through the trees on the left. This card was mailed from Cerulean to Carlotta Gregory in Hopkinsville, Kentucky, on August 19, 1909.

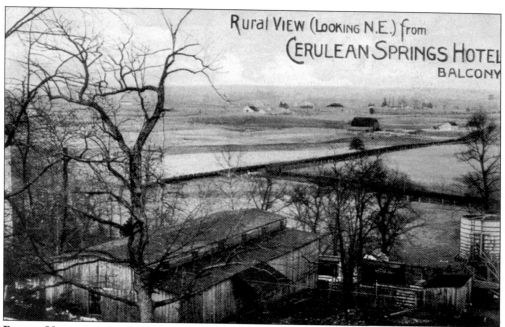

RURAL VIEW. Another hotel postcard gives an extensive scope of subjects. Photographed from the third floor of the annex porch, this picture (from left) shows a corner of the mill, the tobacco factory, the railroad water tank, and farm buildings in the distance. This card was another one of the black-and-white postcards available in the hotel store around 1910.

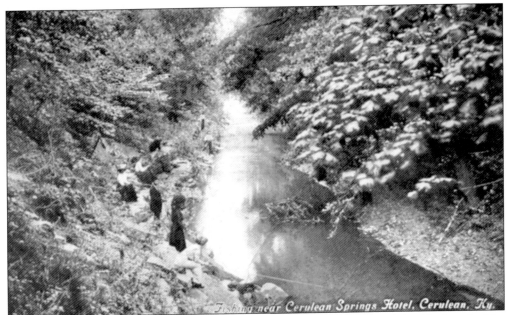

FISHING NEAR CERULEAN SPRINGS. A lady in Evansville, Indiana, received this black-and-white postcard from "Kate" in 1911. The message reads: "A dandy time we are having here, something to do all the time. Yesterday we went driving. Chester is still here and is just lovely to us all." The scene portrays a section of Muddy Fork Creek just below the spring.

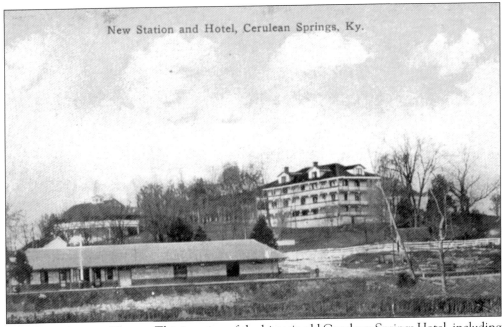

NEW STATION AND HOTEL. This is a view of the historic old Cerulean Springs Hotel, including the dancing pavilion and hotel annex, which guests could see when they arrived by the Illinois Central Railroad about 1910. On July 21, 1908, the Night Riders burned its predecessor, along with the depots at Gracey and Otter Pond. The railroad depot (at left) was built in 1909.

FRANK AND I. Frank is the dog. The man is the beloved and genial host of Cerulean Springs, Confederate veteran Capt. Richard S. "Dick" Pool (1840–1909). Pool and his brother, E. Y. Pool, owned the hotel from 1899 to 1903. Their energy in developing the hotel, the park, and entertainment were limitless. Frank and Dick Pool are seen here relaxing on one of the many hotel park benches, a few of which still survive.

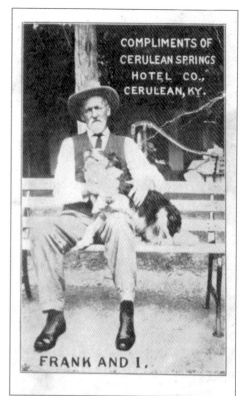

COMPLIMENTS OF
CERULEAN SPRINGS
HOTEL CO.,
CERULEAN, KY.

FRANK AND I.

STAIRWAY TO THE STARS. This photograph shows a group of young people clowning around on the steps that lead to the second-floor guest rooms in the old wing of the hotel. Long dresses, fancy hats, and a dressed up fellow lend an air of formality to their small gathering about 1898.

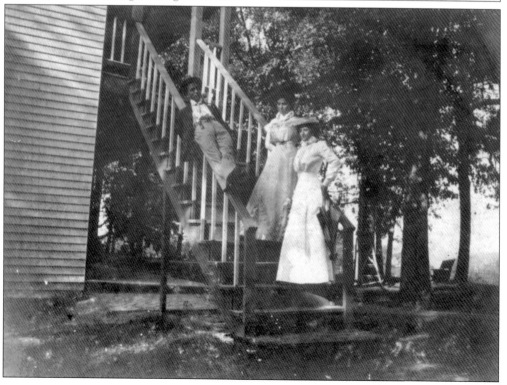

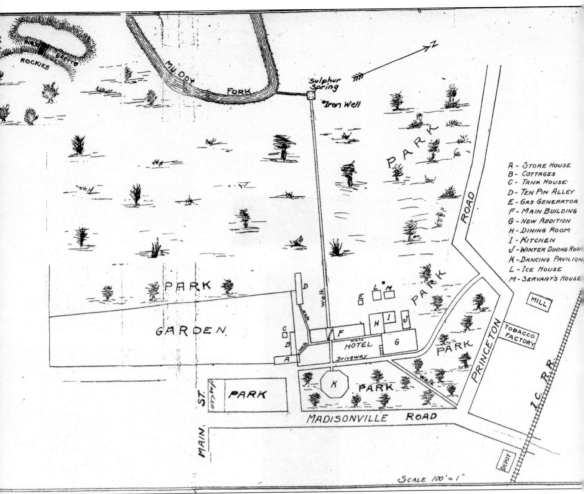

Hotel Plat. This plat of the hotel property, the only one known in existence, was located by the coauthor, William T. Turner, in a deed book at the county court clerk's office in Cadiz, Trigg County, Kentucky. It advertises an auction sale of lots on August 1, 1907. The location of buildings and natural landmarks provides an interesting view of this historical watering place.

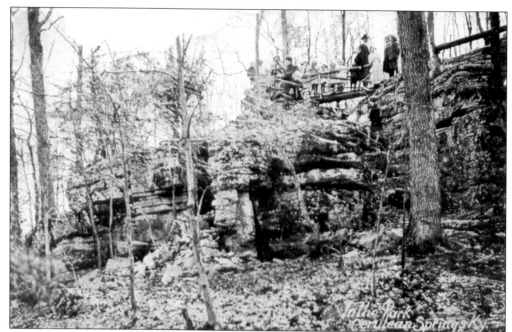

IN THE PARK. A color postcard from about 1905 gives a view of "The Rockeys," one of the hotel park's natural attractions. These outcroppings of rock are located on a bluff overlooking Muddy Fork Creek, downstream from the spring.

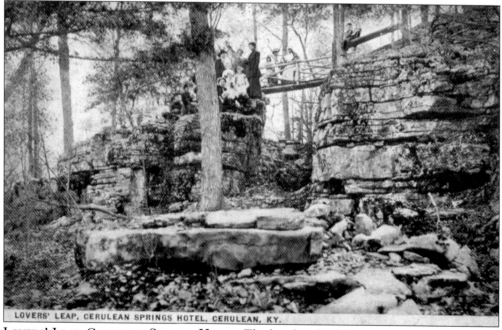

LOVERS' LEAP, CERULEAN SPRINGS HOTEL. The hotel park of about 40 acres included many beautiful limestone rock formations. Lovers' Leap is illustrated in this black-and-white postcard, sold in the hotel store about 1910.

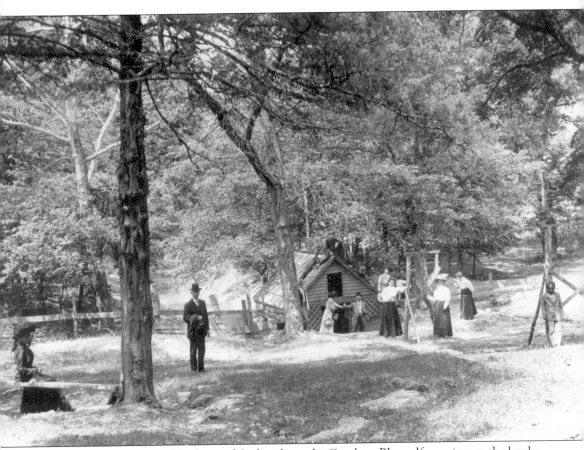

AT THE SPRING HOUSE. The heart of the hotel was the Cerulean Blue sulfur spring on the banks of Muddy Fork Creek, seen here in 1909. In 1792, settler Robert Goodwin found a black sulfur spring where Native Americans were treating their sick. In 1806, his son, Jesse Goodwin, was the first to gain a land title to the spring. The New Madrid earthquake in 1811 transformed the stream into a spring of blue sulfur water. In 1817, Kinchen Killebrew established a health resort with cabins for visitors around the spring. Subsequent owners of the health spa included Joseph Caldwell, William C. Thompson, Phillips Crow, Col. Philemon H. Anderson, Charles H. Anderson, John W. Hicks, John F. White, Jesse T. Harper, W. C. White, John W. Stith, Sam Boyd, R. S. and E. Y. Pool, Tom O. Turner, Bessie I. Murchie, and George A. Hankley. After the hotel burned in 1925, the spring fell into disuse and neglect. Restoration of the springhouse was conducted in 1955 and again in 2006. The spring still flows and the curative water is still available.

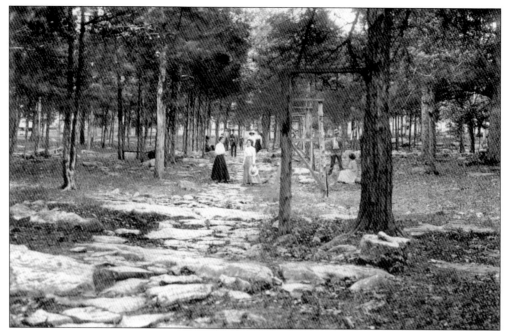

THE WALK UP THE HILL. Another 1909 photograph gives a view of the hotel park looking from the springhouse up the hill to the hotel. A path of limestone rock offered a comfortable place to stroll as people took the waters, breathed the fresh air, and enjoyed the hospitality of Cerulean Springs.

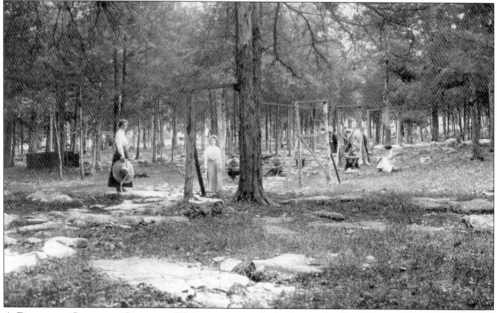

A PAUSE TO CATCH A GLIMPSE. This scene reveals the line of cedar posts to which a cable was attached. A float-equipped bucket connected to a trolley, which rolled along the cable, delivered water from the spring to the back porch of the hotel. There the guests enjoyed drinking, from a common dipper, fresh springwater with a pinch of salt, which was obtained from a cigar box nailed to a post.

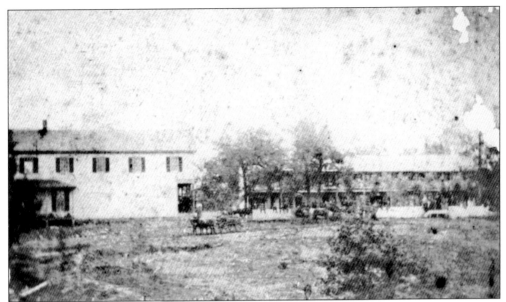

HOTEL STORE AND OLD PART. This earliest known photograph of the Cerulean Springs Hotel reveals the new hotel store (left), built in 1882. It also portrays the old hotel building (right), constructed in 1870. The advertising card promoted "A Superb Quadrille Band," daily hacks (taxis) from Hopkinsville and Princeton, and a good horse stable. This card was printed in May 1883.

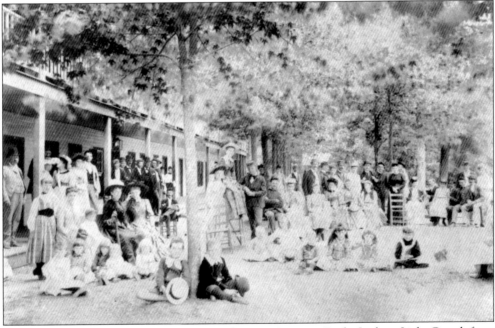

THE MILITARY AT CERULEAN SPRINGS. In July 1890, Company D, the Latham Light Guards from Hopkinsville, went into camp at the hotel. The week's activities included military training, dining, dancing with the young belles, and buggy rides in the opalescent moonlight. This photograph features a mixture of hotel guests and members of the military company.

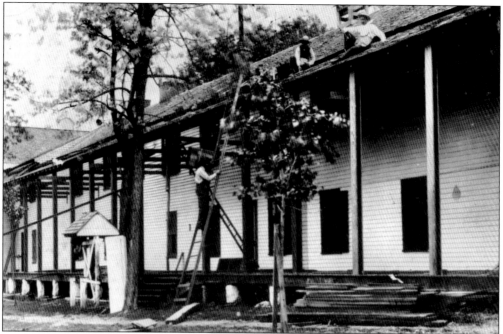

REROOFING. This view features men replacing the wood-shingle roof on the backside of the old hotel. Taken about 1914, this photograph shows the cupola from which the bell rang to announce mealtime. The track carried buckets of water from the spring to the hotel and delivered them to the shingle-covered house. The dining room and kitchen are at far left. Carpenters Berry Shoulders (left) and Dalton Turner (right) are on the roof.

GROUP AT THE HOTEL. In 1916, a group of well-dressed young people appears ready for some special event. This rarely photographed view of the hotel shows the dining room and ballroom (left) and the north end of the old guest-room section of the hotel (right).

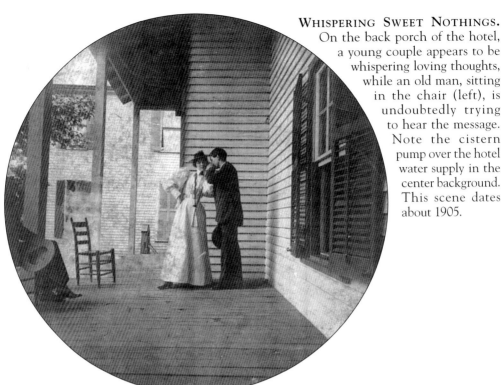

WHISPERING SWEET NOTHINGS. On the back porch of the hotel, a young couple appears to be whispering loving thoughts, while an old man, sitting in the chair (left), is undoubtedly trying to hear the message. Note the cistern pump over the hotel water supply in the center background. This scene dates about 1905.

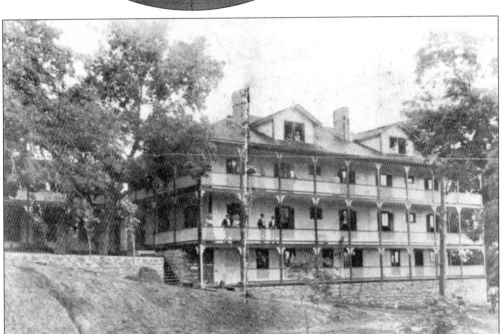

LANDER FAMILY REUNION. For three days in July 1921, a large gathering of members and relatives of the Lander family assembled at the Cerulean Springs Hotel. Reminiscing, picture taking, good food, and a lot of laughter were the orders of that event. This unusual photograph of the hotel, which was featured in the reunion program, shows the annex (right) and the old part (left).

WINTERTIME SCENE. In the winter of 1911, some thoughtful photographer stood on the hotel annex porch and captured this view across the Illinois Central Railroad and the flat farmland beyond. The railroad boxcar (center foreground) was placed there to serve as a temporary station after the Night Riders burned the Cerulean depot.

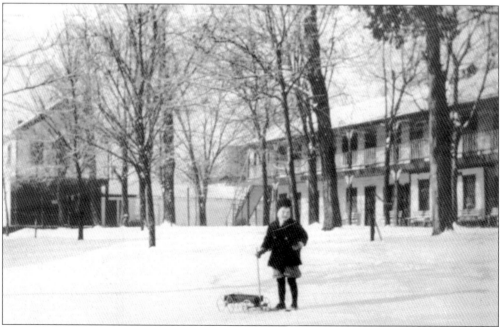

A COLD WINTERY DAY. Young Ben Jones Jr., of Nashville, Tennessee, stands with pride beside his little red wagon on a snowy day in 1911. There were 14 inches of snow on the ground. The scene illustrates the store (left) and the old hotel (right), with the water-storage tank barely visible in center background.

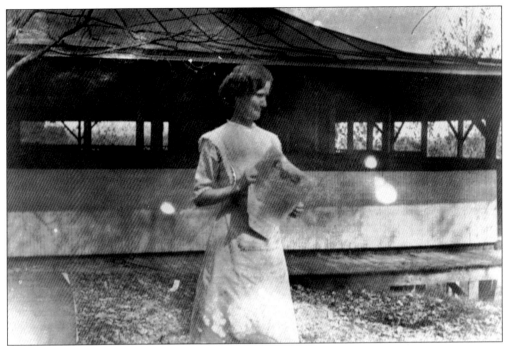

CERULEAN BELLE. Myra Word, of Beverly, Kentucky, glances over a newspaper to look for her beau. The dancing pavilion and skating rink can be seen in the background. These two scenes and the two on the facing page were made in 1908.

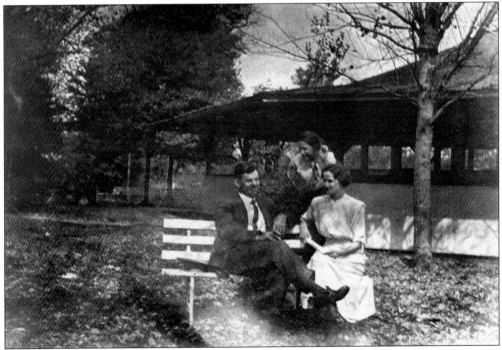

A LITTLE COMPETITION. As Cerulean belle Myra Word corners a beau on a hotel bench, she briefly experiences competition from another young lady.

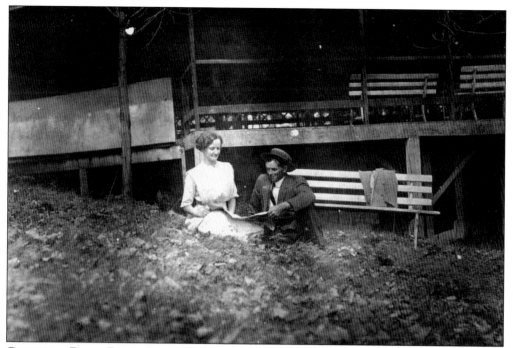

CERULEAN BELLE FINDS BEAU. Now, look-a-here, Myra Word has found her beau, and they jointly look over the newspaper. A collection of hotel park benches at the dancing pavilion awaits additional guests to join them.

CERULEAN BELLE LOSES BEAU. The skating rink stands as a silent sentinel as the Cerulean belle loses her beau to another young lady. Long a hotel landmark, the pavilion and rink stood high on the slope of the hill overlooking the road from Cobb and Princeton.

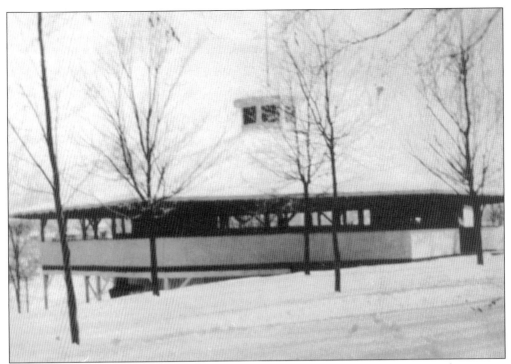

PAVILION DRESSED IN WHITE. In 1911, after the crowds of young people had departed to resume their normal daily lives, the dancing pavilion stood solitary after a snowfall. In the fall of 1877, a Hopkinsville newspaper, the *Kentuckian*, reported that "Since the Springs have closed and Mr. Harper has returned to his farm everything down there looks as still as the grave and as lonely as the devil during a protracted meeting."

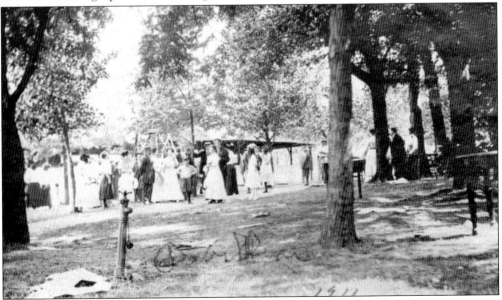

A GROUP AT THE HOTEL. In the summer of 1911, a group of hotel guests stand on the front lawn between the hotel and the dancing pavilion. A water system powered by a ram had been installed, as is obvious from the water hydrant in the left foreground.

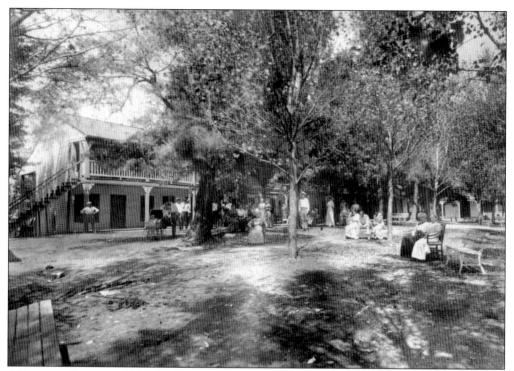

A LEISURE GATHERING. In the summer of 1914, guests are gathered on the lawn of the old hotel. The stairway (left) leads to second-floor guest rooms. Resort owner Tom Turner stands to the right of the tree pictured in the center.

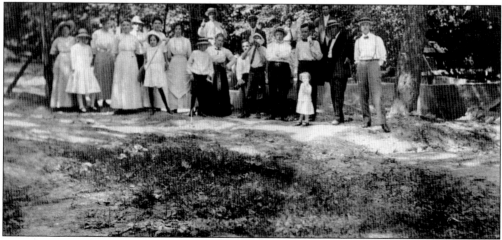

HOTEL VISITORS. In the summer of 1916, another group of hotel "water boarders" has gathered for a photograph. Note the formal dress of that era.

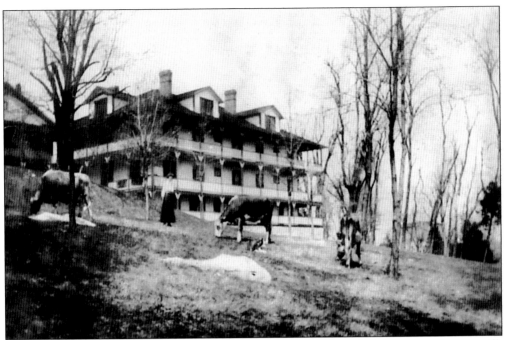

CATTLE-BRAND LAWN MOWERS. On an early spring day, a young lady keeps watch over milk cows from the hotel farm. The cows are grazing the hotel lawn in front of the annex in the days before power mowers. Faintly visible in the right background is the Cerulean mill.

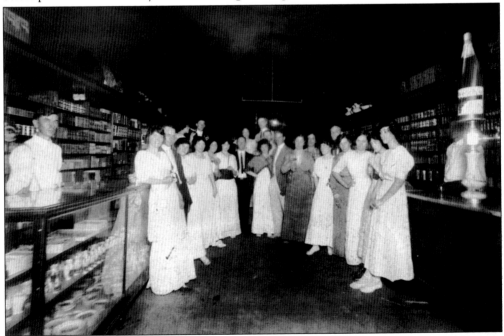

GRAPE JUICE, DISHES, AND WHISKEY. A rare photograph of the hotel store in 1910 features a mix of people. Gaslights illuminate the place, which sold grape juice—the predecessor of soft drinks—from a soda fountain, hotel souvenir dishes (in the counter at left), and whiskey (available at the back of the store). Poker and other entertainment were available on the second floor.

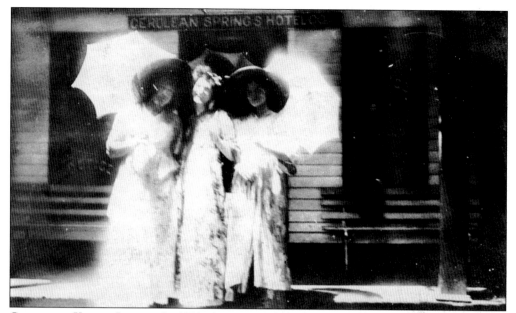

CLOWNING YOUNG LADIES. In 1909, three young ladies, decked out in summer attire, stand in front of the hotel office. The office was located on the first floor, in the center of the old part. Notice the sign over the door.

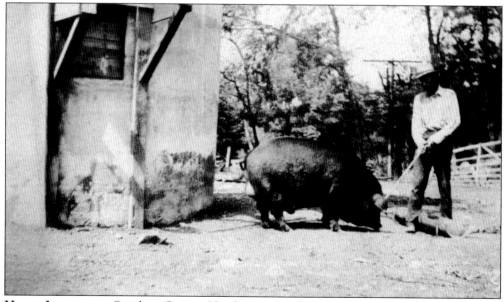

HOTEL LIVESTOCK. Cerulean Springs Hotel maintained an operating farm of about 120 acres. Hog meat was a standard part of the menu. Pictured here in 1914, hotel owner Tom Turner stands with one of the hogs near the concrete silo. The silo is the only remaining hotel landmark.

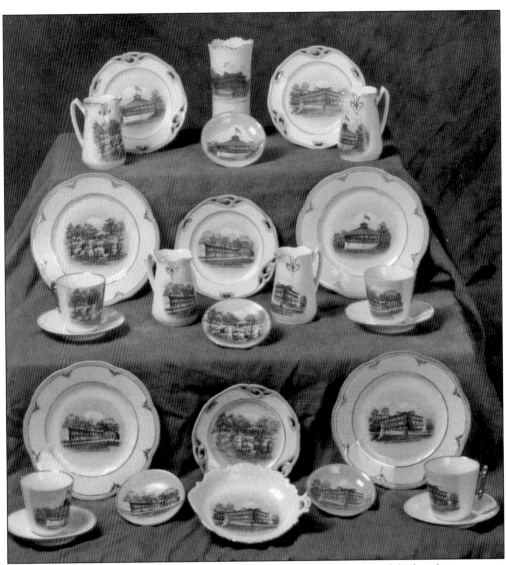

HOTEL SOUVENIR CHINA. The most valuable and sought-after keepsakes of the hotel are souvenir china. These collectibles were made in Germany and imported by C. E. Wheelock and Company in Peoria, Illinois, for the Cerulean Springs Hotel Company some time between 1905 and 1910. This china was sold in the hotel store, and the following four scenes were featured: the new hotel, the old building, the dancing pavilion, and the rock formations. The china was made of kaolin, the white clay required for the making of fine porcelain, in factories from Bavaria, through Bohemia and Saxony and into Silesia. The scenes were transferred and/or painted on the porcelain after the second firing. Engravers produced at extremely low cost the copper and steel engravings used to print the transfer decals for souvenir china. The decals were then burnished onto the pieces of undecorated porcelain. When color images were depicted, the scenes were hand painted before being transferred onto the china.

THE BRIDGE TO LOVERS' LEAP. These young ladies are out for a walk in the hotel park. They are standing on the bridge leading to Lovers' Leap, one of several rock formations on the bluff of Muddy Fork Creek downstream from the spring.

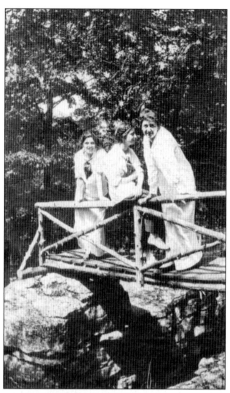

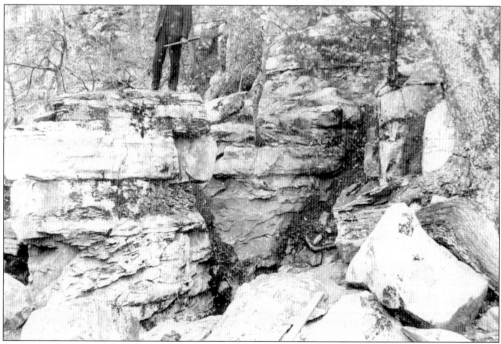

THE ROCKEYS. Between 1900 and 1915, in the heyday of the hotel, owners R. S. and E. Y. Pool and Tom Turner capitalized on natural landmarks as "calling cards" for advertisement. The "Rockeys" (pictured) were a part of that appeal.

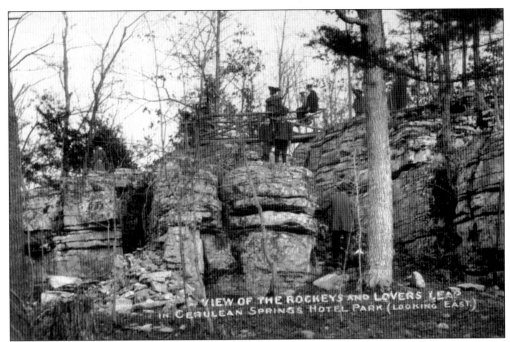

THE ROCKEYS AND LOVERS' LEAP. In 1914, Hopkinsville photographer W. R. Bowles shot this scene in the hotel park. A wooden bridge connected the two formations. Other rock formations included Courtship Walk, Pulpit Rock, Coronation Chair, and Acceptation Avenue.

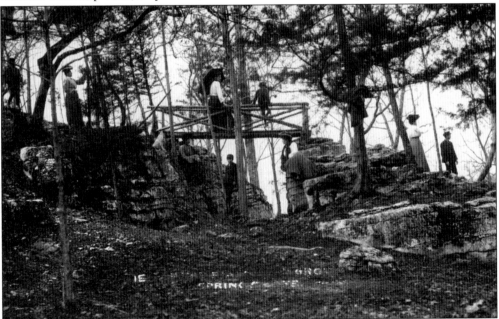

THE RIALTO AND THE GROTTO. The Rialto and the Grotto were among the more familiar rock formations in the hotel's park. W. R. Bowles took this photograph in 1914. An 1880-issue newspaper reported, "The mouth of a cave was opened last week in this rock formation. Proceeding forty feet into the cave a well-preserved skeleton was found. Contact with the outside air, when removed, caused the skeleton to crumble to pieces."

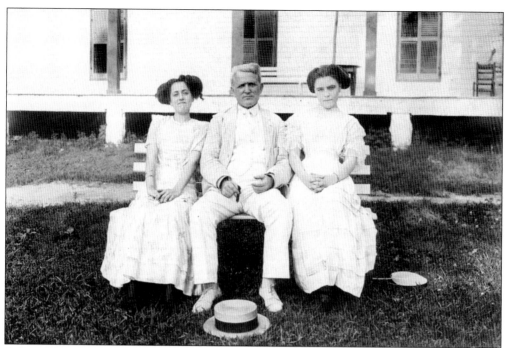

A POLITICIAN AT CERULEAN SPRINGS. Tennessee congressman John Wesley Gaines, a frequent visitor at the hotel, is pictured with two young ladies as the three enjoy afternoon on the spring side of the old hotel. The season of 1912 was marked by a very large attendance.

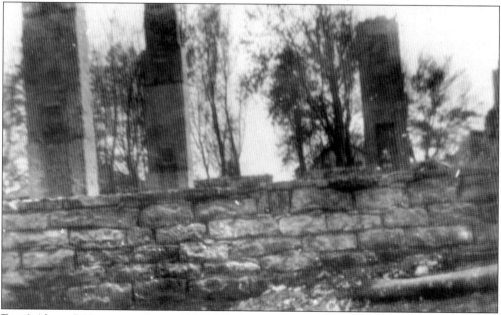

FIRE! About 7:30 p.m. on August 29, 1925, the cry was given that the hotel was on fire. The source was the steam bathrooms in the basement of the annex, where spring water was being heated for mineral baths. Within an hour, the forces of nature were finished, and the historic Cerulean Springs Hotel became a mere memory. This photograph shows the stone foundation of the annex and the facade of the hotel store (right center background).

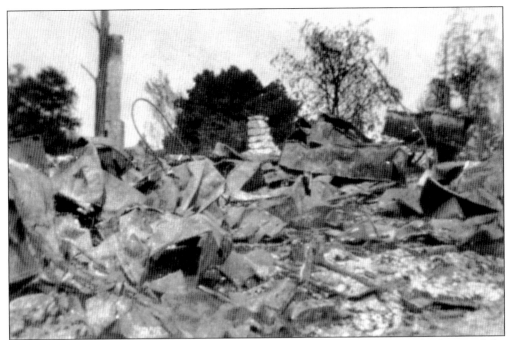

TOTAL DESTRUCTION. A spectacular fire whose red glare painted the western sky destroyed the pride of the Cerulean community 108 years after the hotel opened. Pictured here are the ruins of the dining room, which could accommodate 110 guests. The fire started just after the dining room had closed.

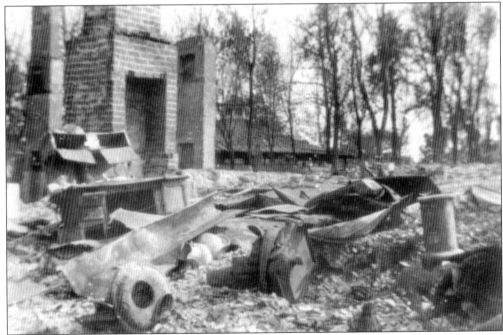

AMONG THE RUINS. The cook stove (left) survived the roaring inferno, which engulfed the two hotel sections, the kitchen, and the ballroom. This picture, looking across the ruins, shows the roof of the dancing pavilion.

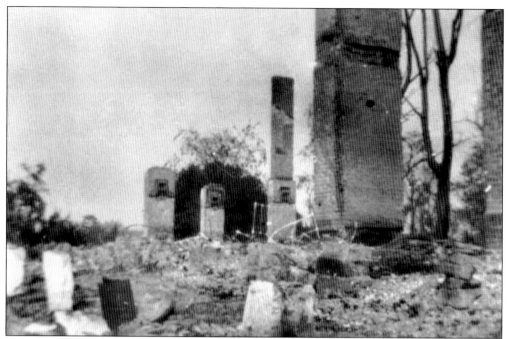

GONE ARE THE DAYS. The fire destroyed the old part (pictured here). The stone pillars of the back porch are visible on the left. This photograph shows the area where the medicinal water of its celebrated spring, drawn by a trolley to the office of the hotel, had been in use for more than a century.

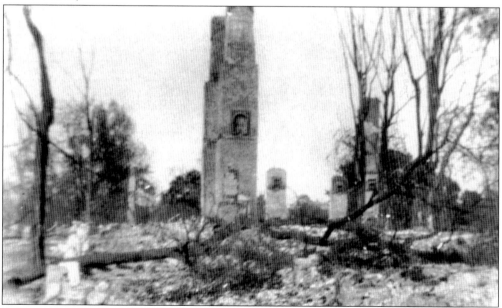

A TREASURED MEMORY. The estimated loss was between $7,000 and $15,000, with the only insurance on a part of the furnishings. With arduous labor, the two-storied store, garage, pavilion, and bowling alley were saved. About 30 guests were registered at the hotel when the fire occurred. "Gone is the old hotel, but there'll ever be blessed memories for its habitues who, in its honor, wear hair the color of its salubrious water," stated the *Kentucky New Era.*

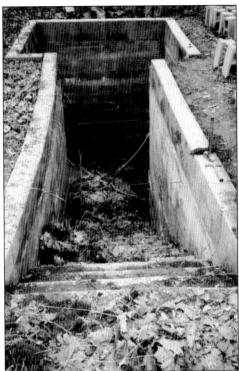

THE SPRING IN DECAY. In 1955, Cerulean residents Cary and Marvin Rawls organized the effort to clean the spring and to build the new springhouse. They supervised the construction of an A-frame roof over a concrete block foundation. The blocks were laid over concrete walls, constructed in 1914, when the spring began to sink. Then-owner Tom Turner hired a crew of men who dug nonstop for 48 hours to save the spring.

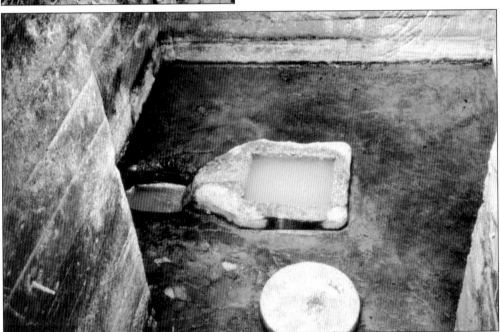

RECONSTRUCTION. After years of neglect, a project was launched in 2006 to clean out the spring pit and to rebuild the springhouse. Retired Cadiz merchant Wallace Blakeley and Christian County historian William T. Turner led the effort to restore the old spring. The building of a replica of the original springhouse, along with the erection of a historical marker, resulted from extensive support by the people who expressed a love for the old landmark.

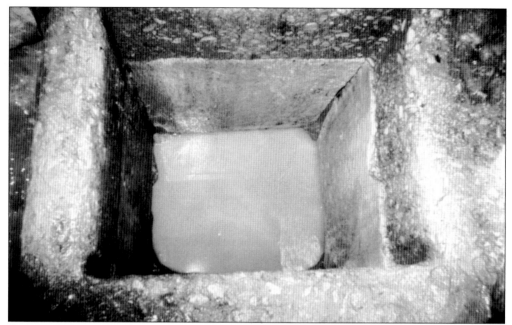

CERULEAN SPRINGS. The spring, 200 years after it was first mentioned in a deed, pours forth the blue sulfur water just as it has since the New Madrid earthquake in 1811. Though the mouth of the spring is now located about 12 feet below the surrounding ground level, it is easily accessible by a concrete stairway. A handsome cut-stone wall was revealed when the throat of the spring was momentarily pumped below the surface.

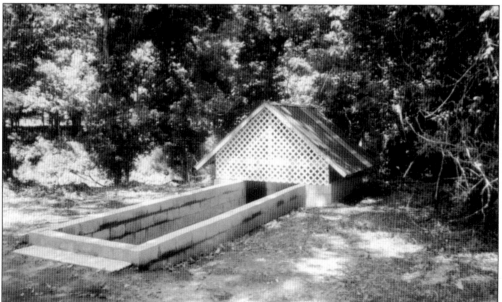

THE NEW SPRINGHOUSE. Many people today hold a fond affection for the stories about Cerulean. These stories, centered on the rambling old hotel and the springhouse, generate great interest among descendents of those who remember the place. This new springhouse, pictured here in 2006, is an example of the commitment of people today who realize that it is vital to keep their heritage alive.

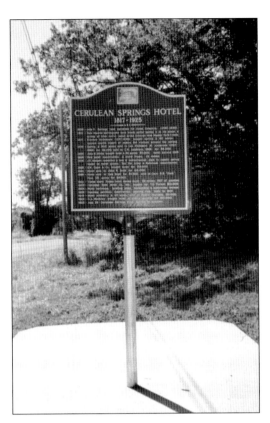

CERULEAN SPRINGS HISTORICAL MARKER. On July 7, 2006, 200 years after Jessie Goodwin registered the first land claim to the spring, a historical marker and the reconstructed springhouse were dedicated. The marker has a picture of the hotel and a brief summary of its history on the face, and the reverse side contains a picture of the mill and the history of the town.

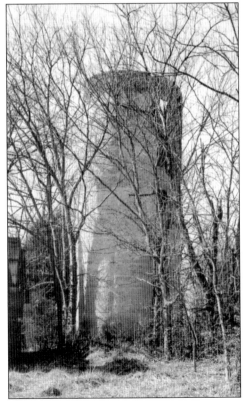

THE OLD SILO. In crude form, yet standing tall in 2006, the hotel silo keeps watch on the hillside. It marks an era that was hot, odiferous, and void of modern conveniences—a slower time when people traveled by horseback, by train, or by the Model T Ford. The era of the Cerulean Springs Hotel was a time when families flocked to resorts to restore health and enjoy leisure activities.

OPENING BALL INVITATION. Pictured here is an 1898 invitation to the opening ball at Cerulean Springs Hotel. The annual event, which became coveted opportunity for a grand old time, was usually held in late May or early June. According to a *Kentucky New Era* account in 1890, "Cerulean was filled with young people from Louisville, Nashville, Hopkinsville, Princeton, and Cadiz, who packed the ballroom with a happy throng, who lingered until a late hour."

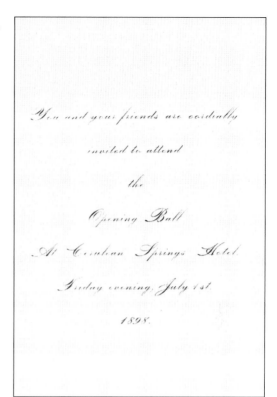

You and your friends are cordially

invited to attend

the

Opening Ball

At Cerulean Springs Hotel

Friday evening, July 1st.

1898.

You are invited to attend the

Annual Opening Ball

at

Cerulean Springs Kentucky

Thursday, June the Twenty-fourth

Nineteen Hundred and Nine

Cerulean Springs Hotel Co.
Incorporated.

ANNUAL OPENING BALL. Shown here is the announcement, in Old English type, of another annual opening ball in 1909 at Cerulean Springs. The 1890 *Kentucky New Era* newspaper article also said, "The assemblage of young people was one of elegance and refinement, and the ball room presented a scene delightful indeed to the spectators, who seemed to enjoy the evening as much as the participants."

CERULEAN SPRINGS HOTEL

OPENING.

✚✚✚

This resort is open the entire year, but on June 1st the summer season will be installed by the opening of the Dancing Pavilion, the Bowling Alley and Skating Rink. The Hotel is modern and up-to-date in every respect, containing more than]one hundred apartments, broad halls and long, cool verandas encircling the entire building, making an excellent opportunity for promenading without getting from under the roof or on the ground. Rooms single and en suite, with individual baths. We can accommodate from one hundred and fifty to two hundred guests.

We have a splendid system of Acetylene Gas lights. Our water works are new and up-to-with individual baths (hot and cold); 900 feet of sewer and convenient closets are also popular features. The whole building has been renovated, repapered and painted. We have a large octagon dancing pavilion in front of the office, and also a new bowling alley, which guests wil have free access to.

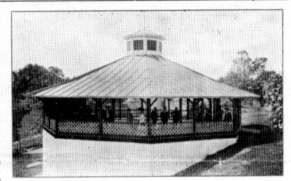

Cerulean Springs Water.

✚✚✚

"Blue, blue, as if the sky let fall,
A flower from its cerulean wall."—Bryant

The water from this spring, as its name implies, is sky-colored in hue; its temperature abour 56 degrees Fahren-t heit, and it is strongly impregnated with sulphur, chloride of lime, soda, bi-carbonate of lime and free sulphuretted hydrogen.

They have a most beneficial action upon the kindneys, stomach and disorders of the skin. They are a specific remedy for rheumatism, gout and neuralgia, in all stages, and in many cases are effective in Bright's disease; an intestinal antiseptic in contagious and infectious diseases, especially where the tongue is coated, foul breath, languor, malaria, fever, jaundice and a tenderness over the liver. Removal of all inflammation of the mucous membranes of the digestive organs and restores the stomach. Within the history of these Springs not a single case of typhoid fever has ever been known. With the altitude, sloping hills and hundreds of feet of drainage pipes, the sanitary conditions are almost perfect.

Amusements.

We have engaged a first-class Orchestra for the season. Dancing and skating every night at the Pavilion and Rink, and on Thursday of each week the grand public ball takes place.

Fishing, trap and target shooting, and a good bowling alley are among the amusements. A first-class livery stable near at hand, with every facility for riding and driving.

The Cuisine....

The cuisine at Cerulean Springs has been long and favorably known as one of the best in the South. We have a large garden connected with the Hotel, from which we supply our table daily with all vegetables in season, and our farm enables us to have fresh milk and butter, shoat, mutton or beef at any time. Registered Jersey cattle and Duroc hogs.

Owing to better and enlarged facilities in every respect, the management hopes, by a very earnest effort, to give their patrons even better satisfaction than ever before. Every effort will be made to keep up and improve the high reputation in this department, which Cerulean Springs has always enjoyed.

THE PARK--A park of 40 acres surrounds the Hotel. It abounds in magnificent wooded hills and curious subterranean caverns, and many other beautiful scenes.

T. O. TURNER, Prop'r. & Mgr., Cerulean Springs, Ky.

CERULEAN SPRINGS HOTEL HANDBILL. About 1914, this handbill was printed and distributed throughout the upper South and the lower Mississippi Valley. It describes the physical layout of the springs and gives information about the mineral water, amusements, and the cuisine. T. O. Turner, then proprietor and manager, owned the hotel from 1903 until 1918.

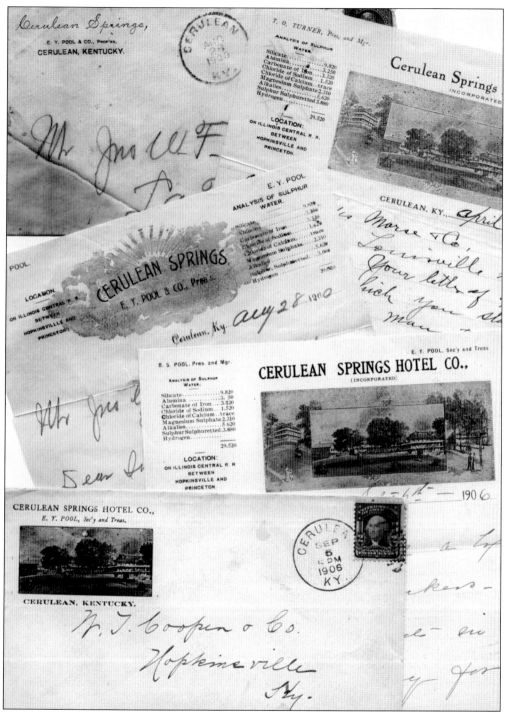

HOTEL LETTERHEAD. Cerulean Springs Hotel stationery is rare. A few examples of printed envelopes and letterhead stationery, pictured here, reveal interesting scenes, various personalities, and an analysis of the water. Dates for the stationery range from 1900 to 1914.

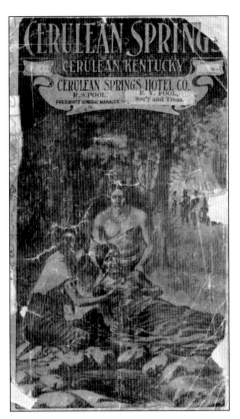

HOTEL BROCHURE. Among the souvenirs and mementos of the Cerulean Springs Hotel, the brochures advertising this watering place are extremely rare. The booklet featured here was printed about 1906. It includes an area history, location, amusements, a description of the springwater, mail, express and telegraph services, and testimonials. It also has a number of photographs.

HOTEL ADVERTISING BOOKLET. W. C. Gray was manager of the Cerulean Springs Hotel Company in 1915, when this 18-page brochure was published. It contained the same information as one published 10 years earlier and even included the same photographs. The Illinois Central Railroad advertised round-trip rates to Cerulean.

NEWSPAPER ADVERTISEMENT. Cerulean Springs, open to the public June 1, advertised the hotel, then under the management of E. Y. Pool and Company. The 1902 advertisement featured a drawing of the new part, then under construction.

Cerulean

Springs:

Open to the Public
June 1st.

Bath Rooms And All
Conveniences.

Write for further information,

E. Y. Pool & Co.

STOCK CERTIFICATE. A Cerulean Springs Hotel Company stock certificate, dated May 19, 1909, lists the capital stock at $25,000. The certificate for three shares was issued to Laura L. Turner, wife of T. O. Turner, president. Shares were listed at $100 each.

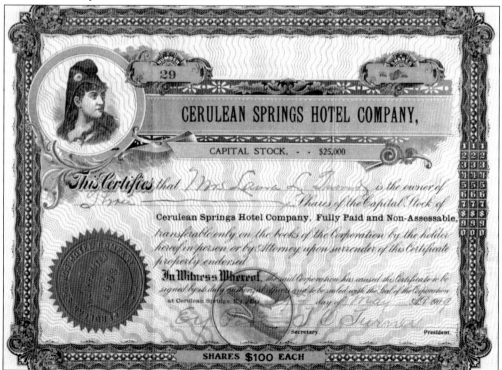

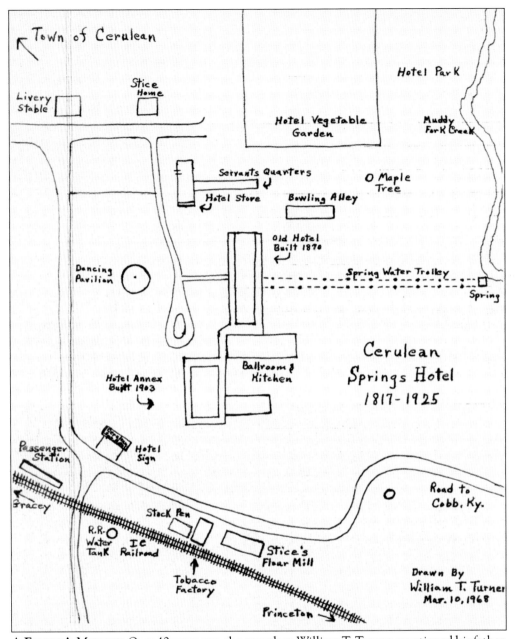

A FATHER'S MEMORY. Over 40 years ago, the coauthor, William T. Turner, questioned his father, W. E. "Gene" Turner, about his memory of the old hotel. William later produced the layout of the old hotel property according to his father's description. This drawing was rendered in 1968.

LEATHER SOUVENIRS.
As people who are interested in the history of Cerulean Springs search the country for souvenirs, every day becomes an opportunity to find treasures relating to this bygone era. A leather glove, with postcard stamped on the back, bears the inscription "A Bird in Hand, Is Worth Two Elsewhere, If It's an Eagle, Cerulean Springs, Kentucky." A scissors-carrier portrays a Native American and Cerulean Springs, Kentucky. These items were probably sold to visitors in the hotel store. Such collectable items occasionally can be located on the Internet.

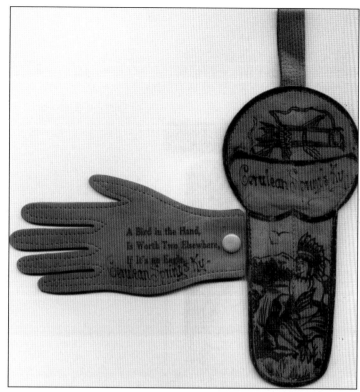

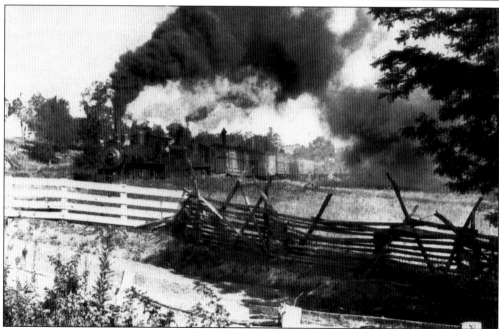

FIRST TRAIN INTO CERULEAN. In August 1887, with the arrival of the first train over the Illinois Central Railroad, life in the Cerulean Springs community was forever changed. Freight cars brought catalog-ordered merchandise, fresh produce, and food products for the hotel. Scores of passenger coaches brought people intent on "taking the waters" for health purposes and to socialize.

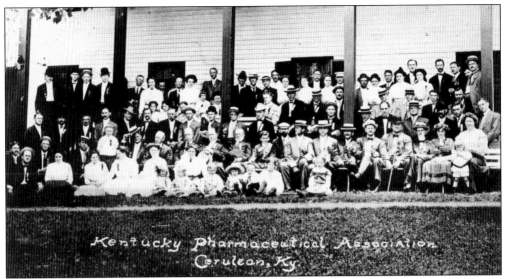

CONVENTION AT CERULEAN SPRINGS HOTEL. Today the Cerulean Hotel's counterpart in Trigg County is Lake Barkley State Resort Park, which attracts numerous conventions. The many social gatherings at Cerulean included family reunions, military encampments, and professional conventions. The group pictured here is the Kentucky Pharmaceutical Association, photographed on the back porch of the old section in May 1918.

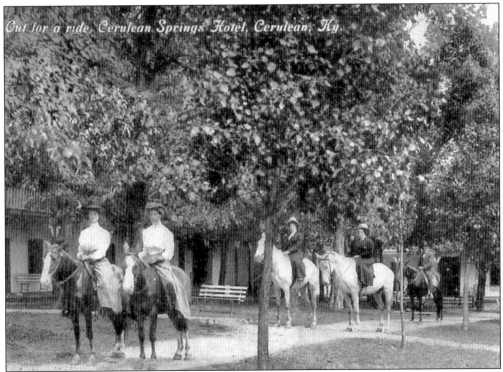

OUT FOR A RIDE. Horseback riding was a favorite experience for guests visiting the Cerulean Springs Hotel. The horses were available from a nearby livery stable. This black-and-white postcard shows one phase of hotel life, viewed in front of the hotel buildings.

PLANTINGS.

1. Plant a falsehood and deficiency, and what will come up?..................

2. Plant a girl's name and a metal, and what will come up?..................

3. Plant a poisonous serpent and a part of the head, and what will come up?..................

4. Plant an unmarried man and something he wears, and what will come up?..................

5. Plant two opposite tastes, and what will come up?..................

6. Plant a fluid found in the animal system, and part of a plant, and what will come up?..................

7. Plant a color and a banner, and what will come up?..................

8. Plant a name of a historical vessel, and what will come up?..................

9. Plant a part of the human frame, and and what would have to be done to it should it be broken, and what will come up?..................

10. Plant a farm product and a drinking vessel, and what will come up?..................

11. Plant a kind of conveyance and a commonwealth, and what will come up?..................

12. Plant a bird and one of its parts, and what will come up?..................

Name the Composers

OF THE FOLLOWING OPERAS

By Composer is meant the **musical author** not the **writer**.

1. Aida..................

2. Siegfred..................

3. Carmen..................

4. William Tell..................

5. Il Trovatore..................

6. The Huguenots..................

7. Lohengrin..................

8. Marguerite..................

9. Parsifal..................

10. Cavalla Rusticanna..................

11. Barber of Seville..................

12. Don Juan..................

MUSINGS AT THE SPRING. The Kentucky Pharmaceutical Association met at Cerulean Springs from June 15 to 18, 1909. These thought-provoking cards challenged convention-goers in their knowledge of such subjects as forestry, composers, and plantings.

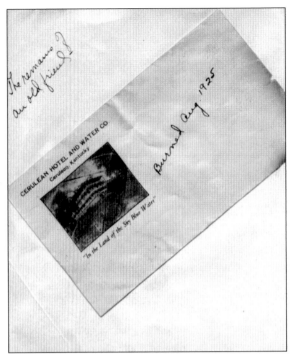

A Singed Memory. Shortly after the fire that destroyed the hotel on Saturday night, August 29, 1925, some individual looking through the scattered debris was thoughtful enough to pick up a hotel envelope. The singed envelope gives poignant testimony of the great loss. In its last days, the hotel company bottled and shipped the spring sulphur water throughout the country, thus the name Cerulean Hotel and Water Company.

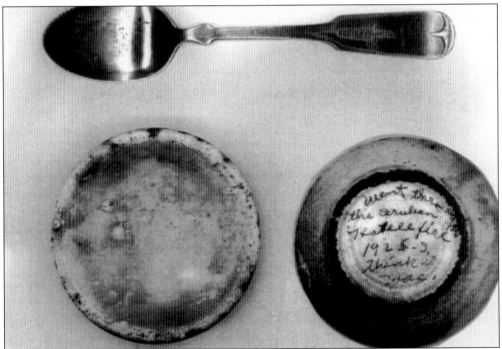

Relics from the Fire. In the weeks following the fire, Cerulean enthusiast Ellen Tribble Blakeley, while looking through the ruins, located and retrieved from the ashes a china butter patty and a silver-plated teaspoon with the inscription "Cerulean Hotel" stamped on the handle. These treasured mementos from the hotel are now owned by her children Wallace M. Blakeley of Cadiz, Kentucky, and Ruby Blakeley Carter of Hopkinsville, Kentucky.

Two

TOWN OF CERULEAN

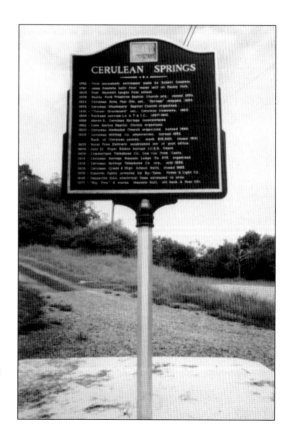

ALL ROADS LEAD TO CERULEAN.
Approaching the town of Cerulean from
Princeton on Highway 126, this historical
marker provides the information that
one is finally there. Cerulean—the name
reminds people, old-timers and newcomers
alike, of a place where many memories
were generated and where a few folks love
to live.

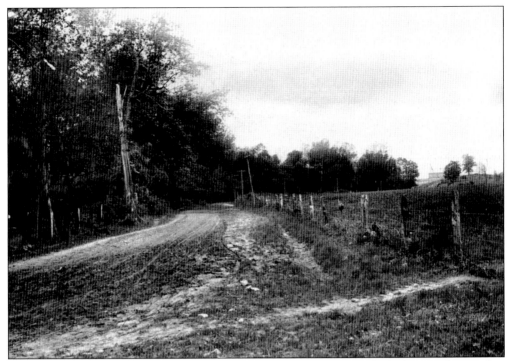

THE ROAD FROM CERULEAN. The year was 1911, the road was dirt, and telephone poles stood as mileposts along the way. A traveler by foot, by horseback, by wagon, by buggy, or by surrey would observe this view upon leaving Cerulean Springs for Cobb or Princeton.

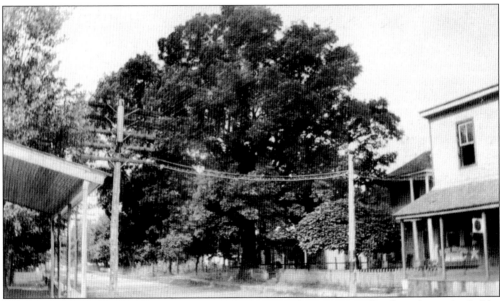

FROM LITTLE ACORNS MIGHTY OAKS GROW. A part of Main Street has long been shaded by the old oak tree still growing in the yard of the W. R. Turner home. It has witnessed a cavalcade of local events as generations have come and gone.

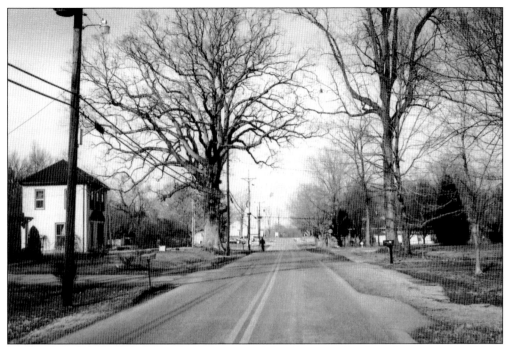

YEARS LATER, FROM THE OPPOSITE DIRECTION. Main Street in Cerulean Springs, pictured here in 2006, reveals a blacktop road, telephone and light lines, and a security light. Paper boxes serve as mileposts along the way. One can only imagine what changes the old oak tree has witnessed with the passing of time.

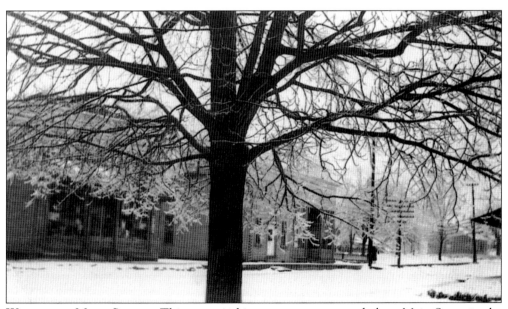

WINTER ON MAIN STREET. This snow and ice scene was captured along Main Street in the 1930s. Weller's Drug Store is located at left with Rawl's Cash Store next door. The Muddy Fork Primitive Baptist Church can be seen in right background.

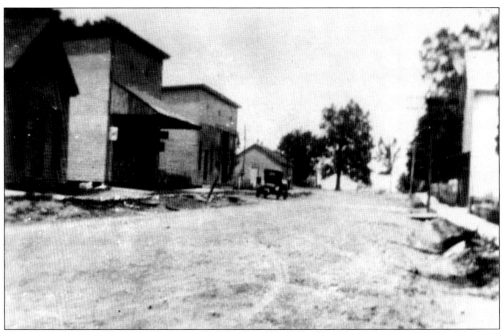

SUMMERTIME ON MAIN STREET. A Model T Ford is parked on the edge of a dusty street on a summer day around 1920. This view shows a row of stores, along with the Masonic Lodge (right), which was consumed by fire in April 1971. The Muddy Fork Primitive Baptist Church appears in the center background.

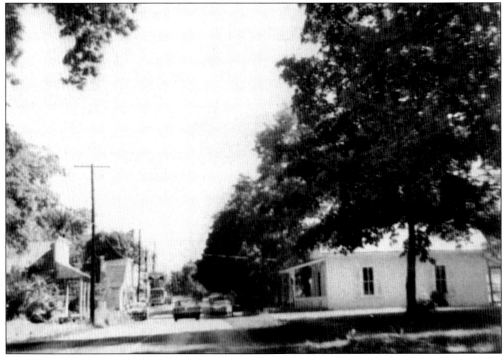

SPRINGTIME ON MAIN. Pictured here *c.* 1971, Limbs of the big oak tree shadow Main Street. The medical office of Dr. John G. White can be seen at right.

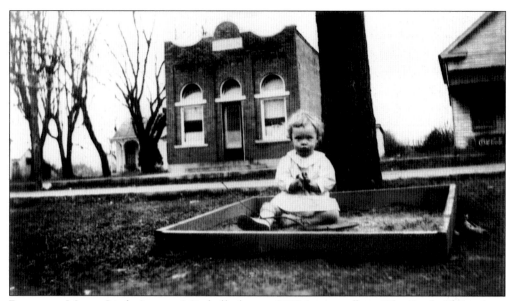

BANK ON MAIN. Little Janette Mitchell plays *c.* 1938 in a sandbox. The Bank of Cerulean Springs (background) was organized June 8, 1903, and was opened September 23, 1903, with a capital stock of $15,000. On December 10, 1941, the bank closed due to deficiency of funds. Bank resources consisted of $101,830.

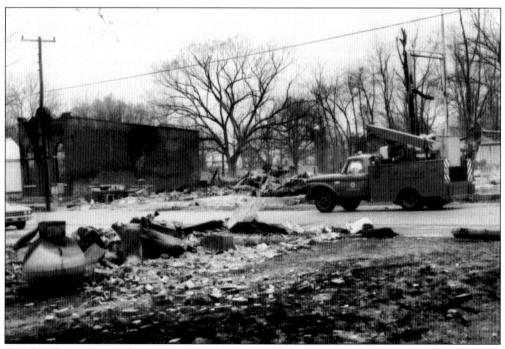

THE BIG FIRE. On April 4, 1971, the business section of Cerulean was destroyed by fire. The pre-dawn Sunday blaze hit during a high wind and destroyed the post office, the old bank building, two grocery stores, and two residences. The fire started in the rear of Howard Hopson's store and was finally brought under control by early afternoon. This scene shows the ruins of the old bank building as linemen repair telephone and electric service.

MASONIC LODGE HALL GONE. This photograph, taken the morning after the big Cerulean fire of April 4, 1971, shows the ruins of the Cerulean Springs Masonic Lodge. In the panic of the event, no one attempted to save the lodge records.

GARDNER'S STORAGE BUILDING. Paul Gardner conducted such a large business that a storage building was required to house the inventory. This building, pictured here in 2006, stands on Main Street next to the site of the store that was destroyed by fire. The Muddy Fork Primitive Baptist Church can be seen in center background. The Cerulean Post Office was temporarily located here until the new building was constructed in 1972.

Three

PERSONALITIES

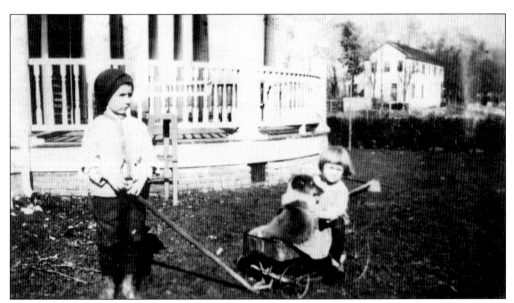

CHILDREN AT PLAY. The Stice children, Billy and Sarah "Peter Bird," are hauling their dog around in the yard of the Stice home. A rear view of the hotel store (right) dates this image to about 1914.

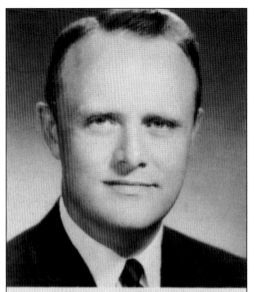

NED BREATHITT

Candidate for GOVERNOR

Democratic Primary, May 28, 1963

GOV. EDWARD T. BREATHITT. Edward T. "Ned" Breathitt (1924–2003), son and grandson of Cerulean natives, served as governor of the Commonwealth of Kentucky from 1963 to 1967. His grandparents were M. Alex Wallace (1864–1951) and Eva Southern Wallace (1867–1929). Alex Wallace was a farmer near Cerulean, and he served as sheriff of Trigg County, 1902–1905. Their only daughter, Mary Jo Wallace (1898–1968), married Edward T. Breathitt Sr., and they were the parents of the governor. The campaign card features Ned Breathitt in his race for governor in 1963. The future governor is seen about 1935 in the family snapshot below with his parents and his grandfather.

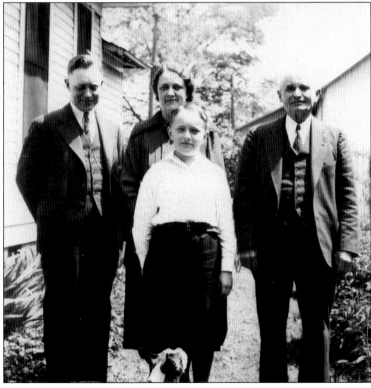

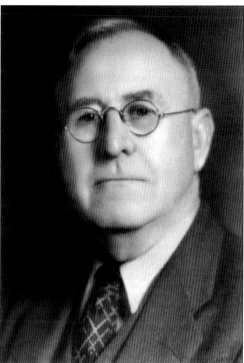

COUNTY JUDGES FROM CERULEAN. J. Lloyd Blakeley (right) (1875–1943), farmer and stock raiser, was born near Buie's Knob. In 1898, he married Mattie Turner, and they had four children. He served Trigg County as judge from 1933 until his death. Lee C. Hopson (left) (1893–1957) was also a farmer in Cerulean. He married Bessie Sizemore in 1916, and they had two sons. Judge Hopson was in office from 1946 to 1957.

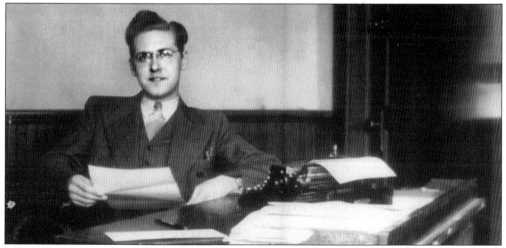

PAUL P. GARDNER JR. A schoolteacher, principal, and native of Cerulean, Paul P. Gardner Jr. (1920–2003) was in the first graduating class of Trigg County High School in 1938. He received his bachelor's and master's degrees from Western Kentucky State Teachers College. He taught at Cerulean Grade School from 1940–1942 and at Trigg County Junior High School from 1955–1971. He was awarded the Eagle Scout rank and was active in the Cadiz Civitan Club and the Trigg County Historical Society.

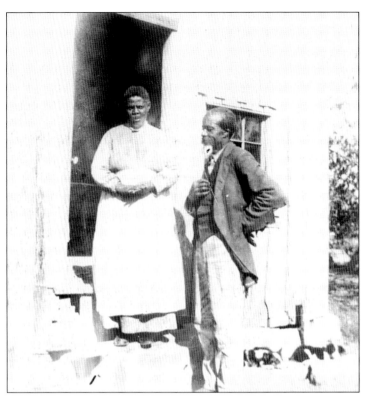

SOL AND KITTIE GOODWIN. Born into slavery, died in freedom, Sol and Kittie Goodwin "Goodin" became community institutions. Sol, born in 1858 into the slave family of Capt. Grandison G. Goodwin, was considered a part of that family. He was a farmer; however, he was best known as a "chicken dresser" at the Cerulean Springs Hotel. Sol married Kittie Gardner (1855–1930). He died in 1951 and was buried in the old Goodwin graveyard.

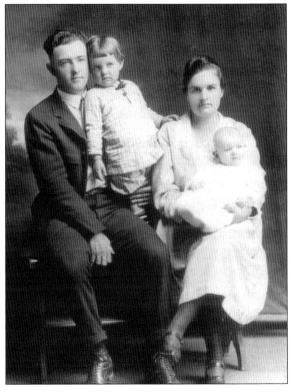

THE ALVIN GOODWIN FAMILY. Alvin "Dobbs" Goodwin, his wife, Lucy Nichols of Wallonia, Kentucky, and their children, E. F. (standing) and Grace (on her mother's lap), portray a typical Cerulean family in the 1920s. Dobbs (1895–1976), as Alvin was known, was a Cerulean character. His love for mischief, bird hunting, cooking barbecue, and conversation made him a welcome visitor at many occasions.

DR. JOHN G. WHITE. A native of Cherokee County, Alabama, Dr. John G. White (1871–1945) was one of two beloved physicians in Cerulean whose medical practices spanned the first half of the 20th century. He graduated from Vanderbilt Medical School in 1894 and practiced for over 40 years. The doctor is shown here, in 1917, clowning around in his Model T Ford, with his office pictured in the left background. White married Josephine Southern (1881–1967).

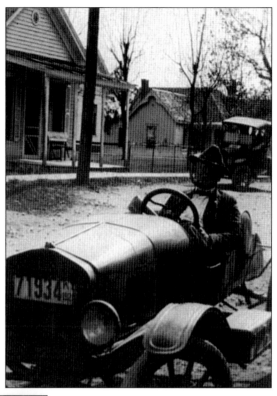

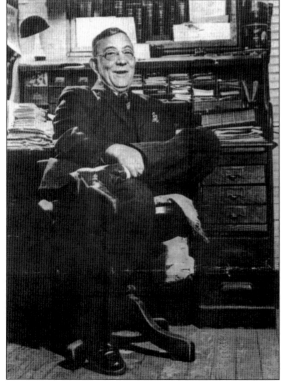

DR. GEORGE E. HATCHER. Dr. George E. Hatcher (1883–1952), a contemporary of Dr. White, was born in Pekin, Illinois, and graduated from Tennessee Medical School in 1905. He practiced at Cerulean from 1914 until his death and is pictured here in his office. Hatcher married Trigg County native Annie Turney (1886–1955).

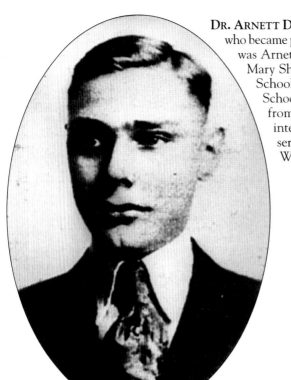

DR. ARNETT D. LADD. The first of two Cerulean natives who became prominent doctors and practiced elsewhere was Arnett D. Ladd (1901–1972), son of E. L. and Mary Shoulders Ladd. After attending Cerulean School, he graduated from Hopkinsville High School in 1920 and received his medical degree from Vanderbilt University in 1928. Ladd interned at Memphis General Hospital and served on the staff of Coffey Clinic in Fort Worth, Texas, for 40 years.

DR. TURNER PURSLEY. Turner Pursley (1900–1945), the son of Robert R. and Minnie Turner Pursley, practiced medicine in Marion, Kentucky. He graduated from Vanderbilt University in 1924, after attending school at Cerulean Grade and High School. In 1941, ill health forced Pursley to retire to his home in Cerulean.

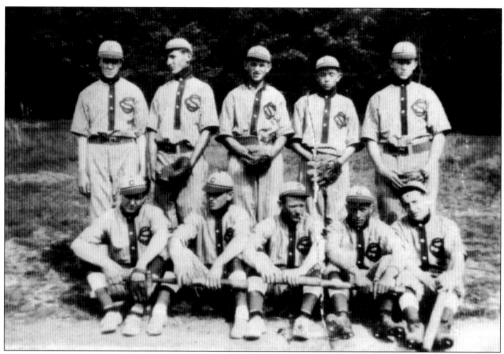

CERULEAN SLUGGERS BASEBALL TEAM. Pictured here in 1917, from left to right, are as follows: (first row) Alva Felix, Will Weller, Fred Solomon, Johnny Sizemore, and Turner Pursley; (second row) Ivan Ladd, Lawrence Felix, John Weller, Leo Stewart, and Elbert Solomon.

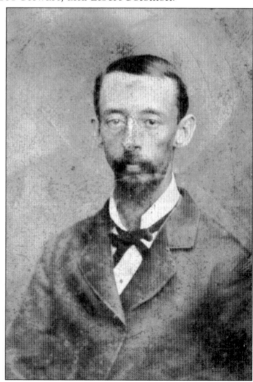

THE OLD CERULEAN SCHOOLMASTER. Bernardino Emelio "B. E." Thom was born in Vera Cruz, Mexico, in 1849. Professor Thom taught at Cerulean Grade School between 1898 and 1906, where he became a beloved personality. The professor was superintendent of Trigg County Schools from 1906 to 1907. He married Emma Hicks, whose father owned the Cerulean Springs Hotel from 1868 until 1879. The schoolmaster died in Doswell, Virginia, in 1932.

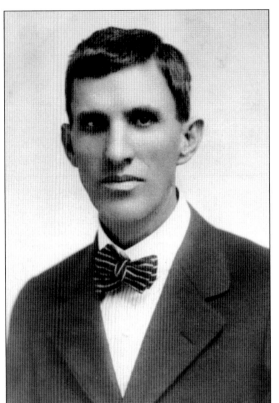

T. O. Turner. Thomas Oscar "Tom" Turner (1872–1955) was a Cerulean community farmer, stock raiser, merchant, hotel owner, and a leader in the Muddy Fork Primitive Baptist Church. In 1914, he moved to Cadiz, where he owned and operated a hardware store, a clothing store, and the Ford dealership. "T. O. T.," or "Tight Old Tom," as he was jokingly known, represented Trigg County as a state senator from 1928 to 1940.

Fetchin' Water. In the summer of 1904, a Cerulean boy was photographed as he and his dog went to a spring for a drink of cool water. The boy was Jeremiah Turner (1899–1904), and he was standing at the mouth of Sizemore's Spring, located behind the Sizemore Boarding House in Cerulean. Jeremiah died November 18, 1904, of diphtheria. The picture became a treasured keepsake for his parents.

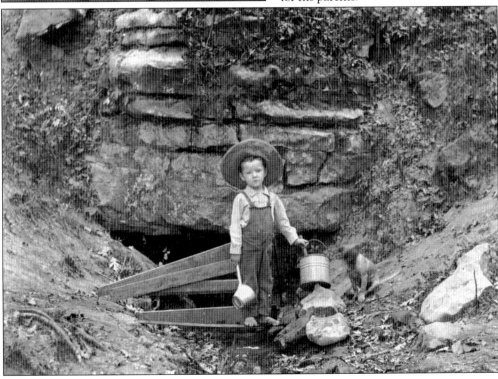

Robert Penn Warren. A Pulitzer Prize–winning poet and the nation's first poet laureate, Robert Penn "Red" Warren (1905–1989) was a grandchild of Cerulean Springs residents. Beginning in 1911, young Warren spent several summers on his grandfather Penn's farm northwest of Cerulean.

Robert Franklin Warren and Ruth Penn Warren. The poet laureate's parents, Robert Franklin "Bob" Warren (1869–1955) and Ruth Penn Warren (1876–1931), were natives of Cerulean. While serving as a clerk in the Belleview store, owned by John Q. McGehee and located on the Cadiz Road between Hopkinsville and Gracey, Bob Warren almost lost his life. A tornado that resulted from the Lucas storm in March 1890 destroyed the store, injuring Warren and killing three others. He moved to Guthrie, where he was cashier at the Farmers and Merchants Bank, and later operated a grocery store. Ruth Penn was born and reared on a farm northwest of Cerulean. She taught at Clay Street School in Hopkinsville from 1894 to 1904. Married in 1904, the Warrens spent their honeymoon at the St. Louis World's Fair. Their three children were Robert Penn, Thomas, and Mary Cecilia.

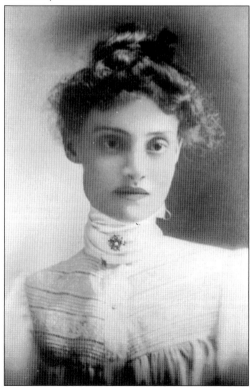

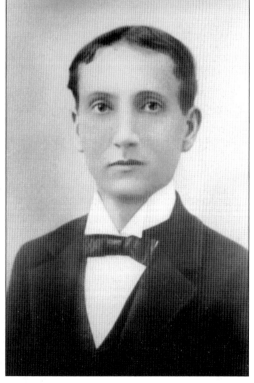

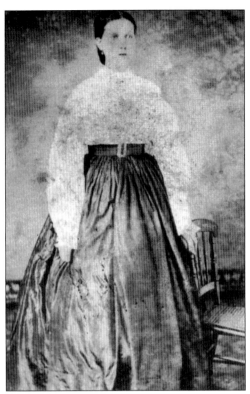

Pvt. William Henry Harrison Warren and Sarah Eliza Pursley Warren. The paternal grandparents of Robert Penn Warren were natives of Cerulean. His grandfather, Pvt. William Henry Harrison Warren (1839–1893), a farmer, served in Gen. Simon Bolivar Buckner's division, 1st Kentucky Calvary, Company B, C.S.A., under the command of Colonel Hallum and Captain Caldwell. "Red" Warren's grandmother, Sarah Eliza Pursley (1847–1877), was a first cousin of James J. Turner, great-grandfather of the coauthor, William T. Turner.

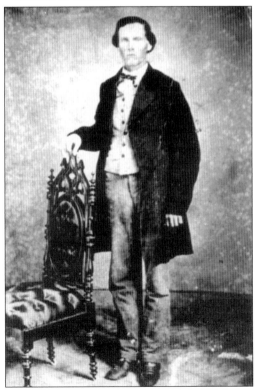

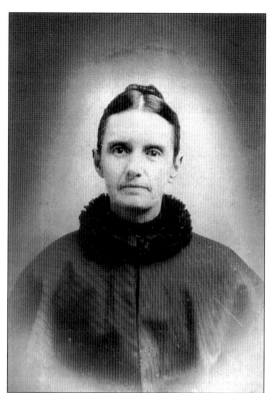

CAPT. GABRIEL THOMAS PENN AND MARY MITCHELL PENN. Capt. Gabriel Thomas Penn (1836–1920), the maternal grandfather of "Red" Warren, was a soldier in Company H, 15th Volunteer Regiment, Tennessee Calvary, C.S.A. Penn, a Cerulean farmer, provided summer education and the enrichment of country life for his young grandson, beginning in 1911. Captain Penn and his wife, Mary E. "Mollie" Mitchell Penn (1846–1898), had seven children.

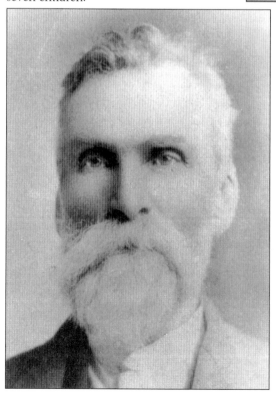

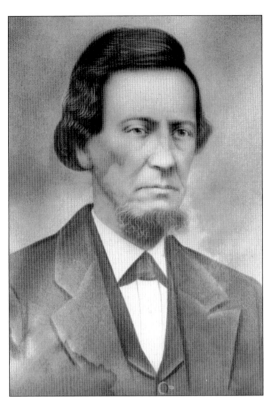

CAPT. GRANDISON G. GOODWIN.
Civil War veteran Capt. Grandison G. Goodwin (1815–1880), a native of the Cerulean community, served as a member of Company B, 2nd Regiment, Kentucky Calvary, C.S.A. He was a successful farmer north of Cerulean. The relationship between Captain Goodwin and one of his slaves, Uncle Sol, was so strong that Sol was buried in the Goodwin family graveyard next to his "Ole Massa."

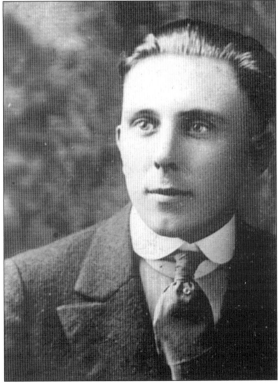

PVT. JOHN J. BLAKELEY, WORLD WAR I. The winds of war brought news by telegram to Cerulean, which said that on September 23, 1918, another one of the town's boys had given his life in the name of freedom. Pvt. John J. Blakeley (1897–1918) had entered the service in late summer, contracted the flu and pneumonia, and died while in basic training.

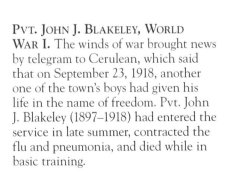

S.Sgt. E. F. Goodwin, World War II.
S.Sgt. Edward F. Goodwin (1923–1944),
Cerulean native and son of Alvin G. and
Lucy Nichols Goodwin, enlisted in the U.S.
Air Force in February 1943. He served as a
radio operator and gunner. While stationed
in Italy, he was a B-17 (Flying Fortress)
bomber crewmember. He was killed in
action April 23, 1944, when he was downed
two miles southwest of Ternitz, Austria.

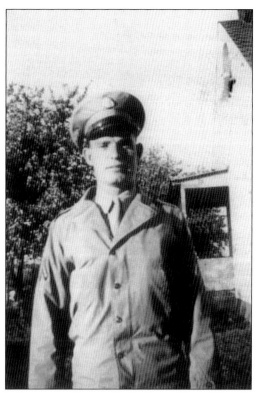

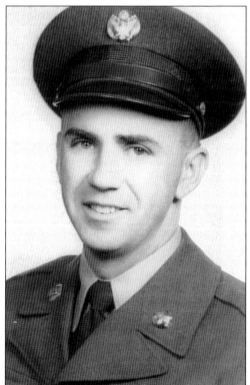

**Cpl. Gilmar D. Burgess, the Korean
Conflict.** Cpl. Gilmar D. Burgess (1926–
1971), born in Cerulean to Charlie W. and
Irene Gentry Burgess, was drafted into the
U.S. Army in 1951. He completed basic
training at Camp Breckinridge in Kentucky.
At Kileen Base in Texas, he served as a
military policeman with the Atomic Energy
Commission. Transferred to the Army
Reserve in 1953, he was honorably discharged
in 1959. Burgess married Janette Mitchell, and
they have one daughter, Dorris.

LT. JERRY ROBERTS, VIETNAM WAR. Lt. Jerry Roberts (1941–1966) served in the U.S. Army from June 1964 until his death on July 5, 1966. He was a helicopter pilot assigned to the 502nd Aviation Battalion and was the son of Elmer and Nola Litchfield Roberts. He married Rita Ezell and they had two children, Maranita and Jerry Vance.

SPC. JASON AMES, WAR IN IRAQ. Spc. Jason Ames (1984–2005), son of Irl W. and Susan Yingst Ames, graduated from Trigg County High School in May 2003. He enlisted in the U.S. Army in June 2003 and was killed on August 31, 2005, while serving a tour in Iraq. Ames received the Army Commendation Medal. He is survived by his parents, his wife, Trisha, and a son, Cody Eric Ames.

Four

HOMES AND BUSINESSES

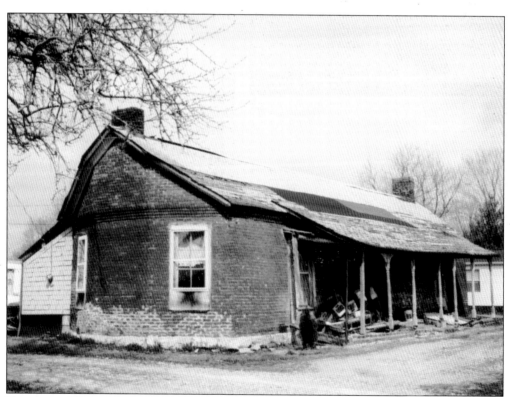

BEARFIELD HOMEPLACE. James M. Bearfield bought 49 acres across from the Cerulean Baptist Church from Charles H. Anderson in 1867. There he built a tapered, cornered, one-story brick home, which remains one of the most unusual landmarks in Cerulean. It was later owned by the P'Pool, Gardner, Wood, Ladd, and Green families. The now unoccupied residence, pictured here in 2006, is owned by Harris E. Boyd.

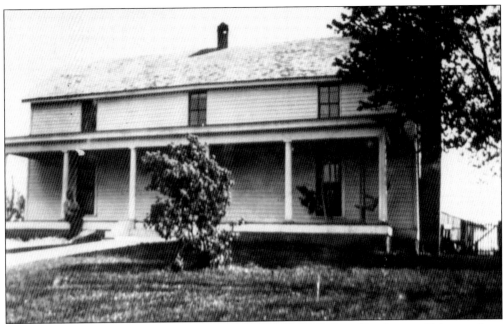

GOODWIN-TURNER-BLAKELEY-DAVIS HOMEPLACE. In 1792, Robert Goodwin and his sons, Jesse and Samuel, made the first permanent settlement in Cerulean. Jesse's son, John Goodwin, and his family settled and built a house on the site of the present Pat Davis home. The land was later owned by succeeding generations in the Turner and Blakeley families until 1949, when it was sold to Pat Davis. Jim Turner built the present home in 1885, pictured in 1920.

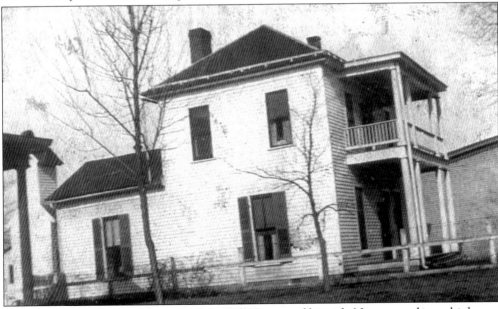

W. R. TURNER HOME. Cerulean merchant Will Turner and his wife, Nora, moved into this home, a one-story bungalow, in 1898. It was enlarged about 1900 with the addition of a second story, a double porch, and the popular kitchen stove vent, pictured at left, in 1919. The family resided here until 1924. The home has seen several families come and go, but in its present condition, its future may be in question.

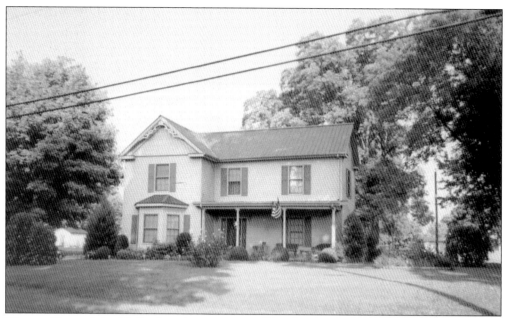

WELLER HOME. John Weller, longtime operator of Cerulean's only drugstore, and his family lived in this home, located on Main Street. The house, built in the 1890s and pictured in 2006, is now the residence of Wilton and Frances Lancaster.

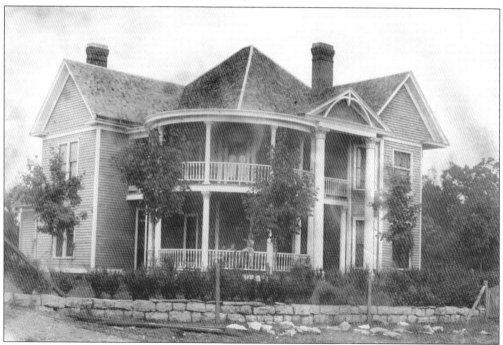

THE STICE HOUSE. William N. Stice (1867–1947) and Sallie Graham Stice (1873–1958), miller and the "Cerulean scribe," were longtime prominent residents of Cerulean. Sallie contributed a weekly column to the *Cadiz Record*. The Stice children were Lois, Eunice, Mary, Rachel, Rebecca, Billy, and Sarah. Their home, which faced the hotel, was built in 1903 and was torn down in 1965 by Gilmer Burgess. It is pictured in 1905.

THE DR. WHITE HOME. In 1905, Dr. John G. White and his wife, Josephine, settled in Cerulean, where he practiced medicine until his death in 1946. Dr. and Mrs. White built this attractive home c. 1906, and it is pictured 100 years later. It is now the home of Sammie and Hilda Bentley.

A CERULEAN LANDMARK HOME. Bob and Nan Pursley Elliott built the Harold Witty home, located on Hopkinsville Road at the edge of town, in 1914. This farm was settled by Samuel Goodwin (1768–1843) in 1792, and it remained in the family until 1955. It is pictured here in 2006.

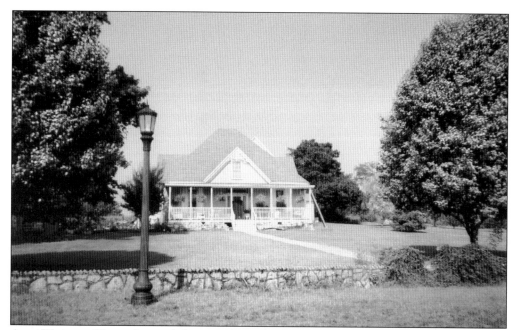

ALEX WALLACE HOME. Located about a mile north of Cerulean, the Alex Wallace home, pictured in 2006, was the birthplace of his daughter, Mary Jo, in 1898. She became the mother of Edward T. "Ned" Breathitt, who was governor of the Commonwealth of Kentucky from 1963 to 1967. The farm was later the home of county judge Lee C. Hopson.

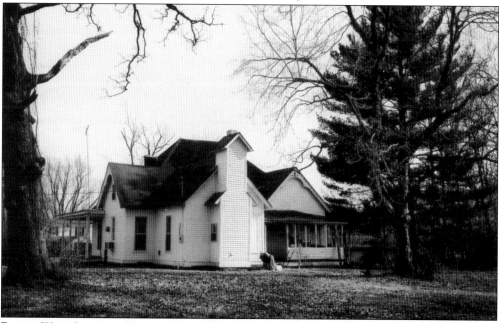

RAWLS-WILL CAMERON HOME, REAR VIEW. Foster A. Rawls, postmaster, and his wife, Olive, built this home (pictured in 2006), located in the curve across from the Muddy Fork Primitive Baptist Church, around 1900. A Cerulean visitor to Texas observed the fascinating style of construction, which aimed to vent kitchen heat. An exterior tower with an enclosed flue from the cook stove drew the heat out of the kitchen. This feature was one of many constructed in Cerulean.

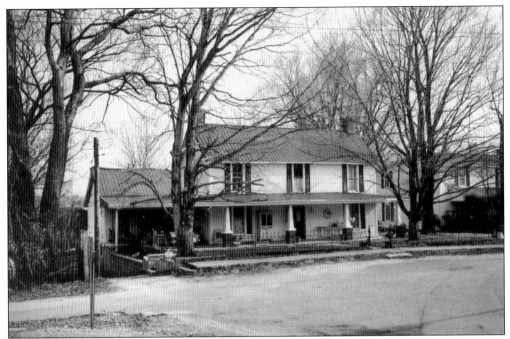

DR. GEORGE HATCHER HOME. Dr. George E. Hatcher practiced medicine in Cerulean from 1914 until his death in 1953. The doctor and his wife, Annie, lived in this home, pictured in 2006, with his office attached (left). It was later occupied by Josephine McConnell Mitchell.

SIZEMORE'S BOARDINGHOUSE. In 1906, Tom and Laura Turner built this large frame residence on Main Street in Cerulean. She operated a boardinghouse here and provided sleeping rooms for overflow guests from the hotel. In 1914, when they moved to Cadiz, Kentucky, Willis J. and Jennie Wood Sizemore bought the home and operated a boardinghouse here until her death in 1946. Bill and Joyce Marshall now live in the home, pictured in 1995.

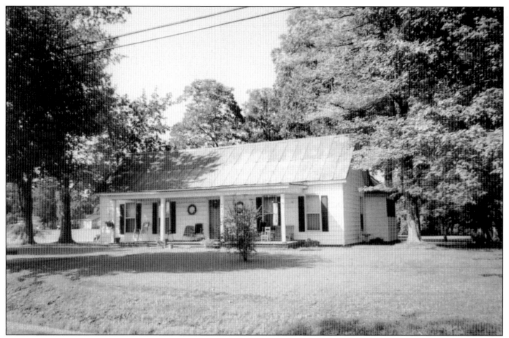

WARREN HOUSE. Another Cerulean landmark, pictured here in 1980, is the home of the late Marvin and Ora Warren Rawls. It was the boyhood home of Robert F. "Bob" Warren, father of Robert Penn Warren, the Pulitzer Prize–winning author. The current residents are Gary and Rose Sanders.

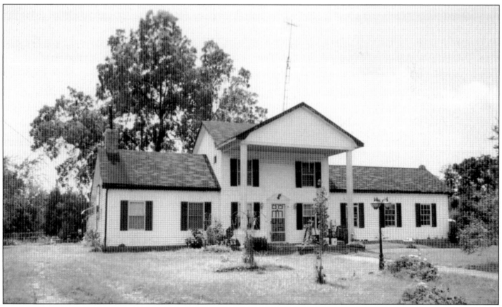

DAVE TURNER HOME. The Turner and Pursley families owned the old Cerulean home pictured here in 1975 for over a century. David R. "Dave" and Susan Stewart Turner reared their family of three children on the income from farming and from serving as the minister of Muddy Fork Primitive Baptist Church. Their daughter, Minnie, married Robert R. "Bob" Pursley, and their family of three children lived here until the 1970s. It is now the home of Irl Ames.

THE VILLAGE BLACKSMITH SHOP. Nathaniel Mann, an ardent consumer of Cerulean Springs water, operated this blacksmith shop for many years. A stopping place for horse and mule shoeing, the shed, pictured in 1988, also served as an assembly point for men to discuss current events.

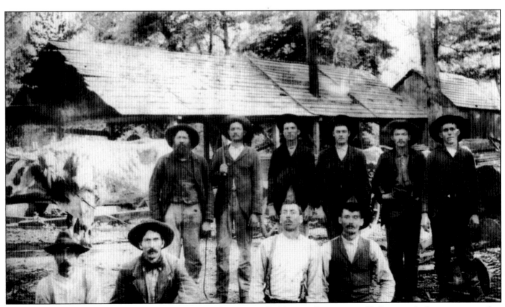

STEWART'S SAWMILL. Anderson Stewart (top row, left) ran this sawmill, located about two miles east of Cerulean, in the 1890s. This operation, along with water mills, were the first business-related activities in the community.

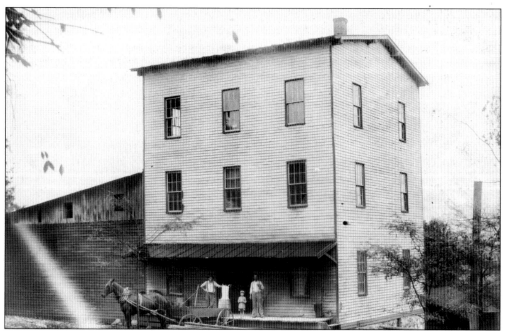

STANDARD ROLLER MILL. In 1903, the family of William Newton Stice moved to Cerulean Springs from Dawson Springs. He constructed this flour mill that same year and operated it until 1946. The mill was located on the Illinois Central Railroad near the depot. It is pictured around 1910.

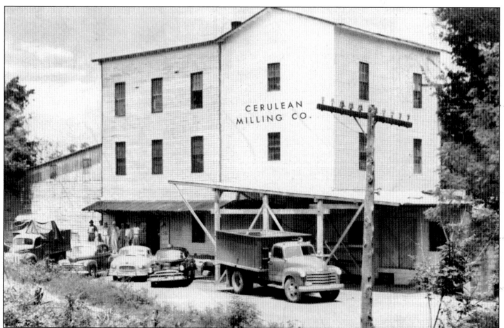

CERULEAN MILLING COMPANY. Sometime before 1925, W. N. Stice built the addition to the mill shown at right. In 1946, the Pryor brothers bought and operated the old Standard Roller Mill under the new name Cerulean Milling Company. Bran dust, always an explosive danger around a mill, caused its destruction by fire on September 21, 1952, the year this picture was made.

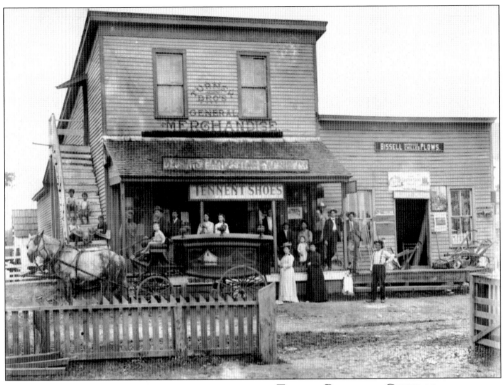

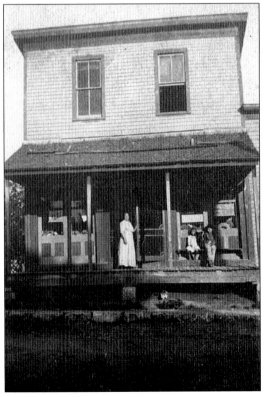

TURNER BROTHERS GENERAL MERCHANDISE STORE. The Turner brothers, Will and Tom, owned and operated this general store on the corner of Main and Turner-Rawls Streets from 1898 until 1907. It was later operated by Will Francis and Cortez K. Warren before being torn down in 1937. A group, photographed above on March 27, 1904, illustrates the variety of society and business activity that took place around a small community store. In addition to the general store, Will Turner operated an undertaking business (as is portrayed by the horse-drawn hearse). Also, at one time, the telephone exchange was located on the second floor. Nora Blakeley Turner and her children, Pauline and Eugene, pause for the camera on the store porch at right about 1912. Will Francis was then the store operator, with Will Turner retaining a partial ownership.

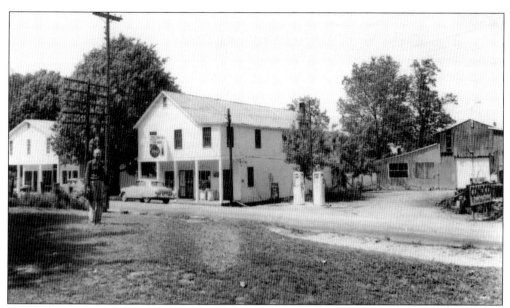

GARDNER'S STORE. Paul P. Gardner Sr., Cerulean merchant and blacksmith, operated this general store (center) and blacksmith shop (right), photographed in 1953, for over 60 years. The building at left was used for storage. He sold groceries, hardware, feed, and Conoco gasoline. The store was destroyed by fire on February 27, 2004.

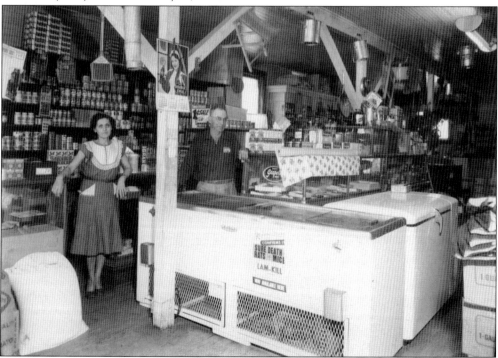

INTERIOR OF GARDNER'S STORE. Florescent lights, canned goods, fly swatters, feed sacks, cases of oil, soft-drink coolers, and oil cloth all identify the interior of a small-town country store in the mid-20th century. Paul P. Gardner Sr. and his wife, Laura, pose for the camera in their store in 1953.

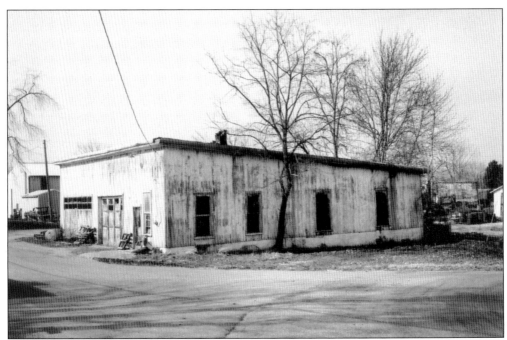

HOPSON'S GARAGE. Another Cerulean landmark with a questionable future is the old Roy Hopson Garage, pictured here in 2003. It was built for use as a livery stable about 1921, and, for a number of years, it housed the Ford Automobile Agency.

BUNCH AT DR. WHITE'S OFFICE. Dr. White's office porch was often a gathering place for young men. Pictured here in 1918, from left to right, are Lige Felix, Alvin Goodwin, Will Weller, Will Rawls, and Fred Solomon.

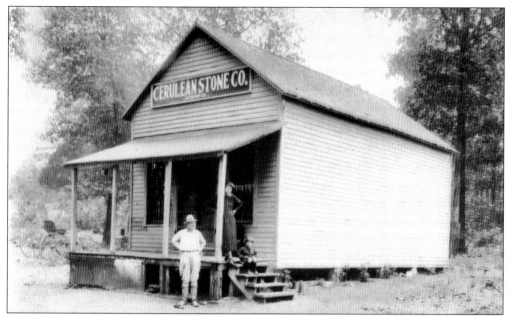

CERULEAN STONE COMPANY OFFICE. In September 1895, James Newton of Newton and Company, with the help of 40 hands, began to quarry rock near the Illinois Central Railroad one mile north of Cerulean. The Cerulean Stone Company acquired ownership of the quarry in the 1920s, was later bought out by the Cedar Bluff Stone Company, and finally was purchased by the Kentucky Stone Company of Princeton in April 1977. Quarry operations ceased in the late 1950s. This picture was made in 1916.

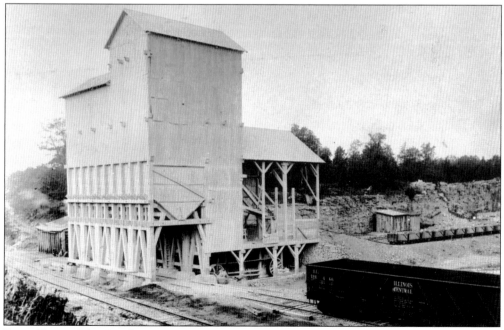

ROCK TIPPLE. The Cerulean Stone Company constructed this rock tipple, pictured in 1916, along the Illinois Central Railroad to facilitate the shipment of limestone rock. The railroad company's demand for ballast made it the greatest customer.

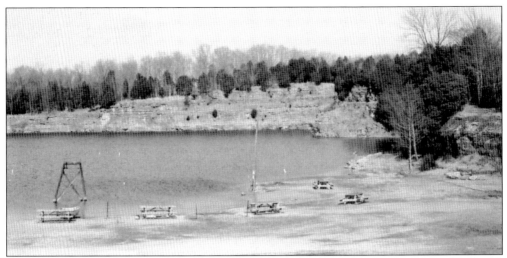

DIVE CERULEAN. In the summer of 1989, when a new use for the old Cerulean quarry was developed, David Westerfield opened Dive Cerulean. The 16-acre lake was converted into a diving resort complete with campgrounds and recreational facilities. It is pictured in 2006.

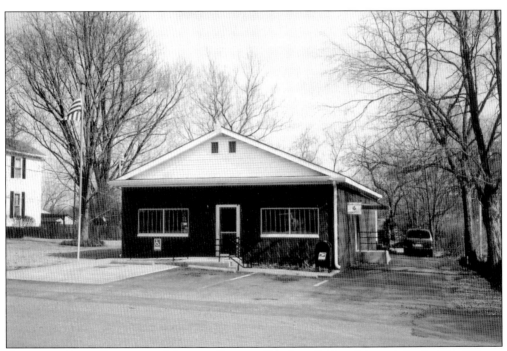

CERULEAN POST OFFICE AND MASONIC LODGE. Cerulean Springs Masonic Lodge No. 875 was chartered on October 21, 1914. The lodge hall and all of its records were destroyed in the big Cerulean fire on April 4, 1971. The lodge constructed this building in 1972 as a meeting place in the rear and leased the front to the U.S. government for use as a U.S. post office. It is pictured here in 2003.

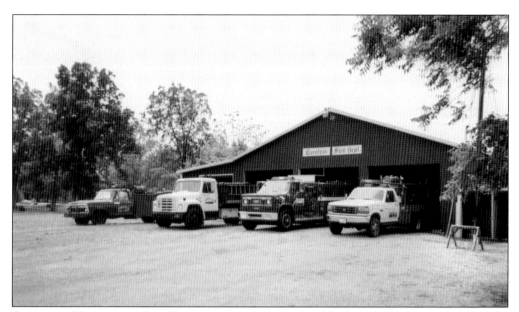

CERULEAN VOLUNTEER FIRE DEPARTMENT. Organized and built in 1971 and pictured in 2006, the department is equipped with four trucks and has approximately 15 firefighters, including Gaylon King, Dabney Rascoe, Jim Hoadley, Dusty King, Mike Brashears, Ed Ethridge, Allen and Nik Coleman, Josh and Steve Brashears, Mark Sowell, David and Tim Ginn, Rick Burgess, and Danny Stewart. Many other residents volunteer with the department.

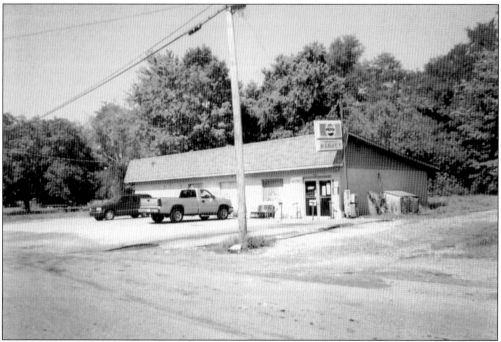

CORTNER'S MARKET. In 1972, Jerry Cortner constructed a new grocery store in Cerulean to replace several stores destroyed by fire the year before. This is the only retail business in the community and is operated by Sue Adams in this 2006 picture. The dying custom of men socializing in a country store is continued at Cortner's Market.

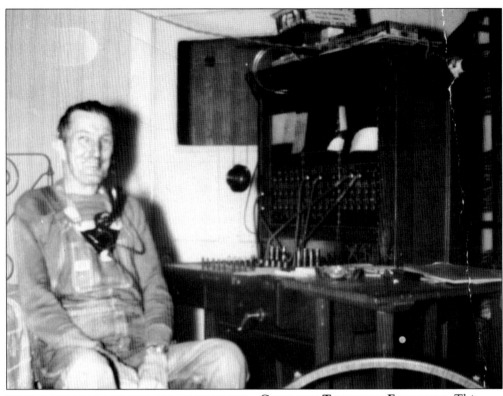

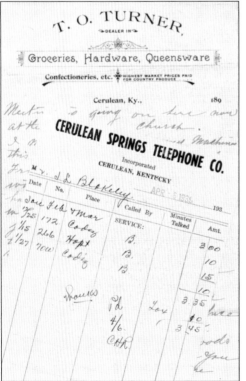

CERULEAN TELEPHONE EXCHANGE. This telephone company was incorporated on March 16, 1918. The exchange was located on the second floor of W. R. Turner's store, and it was later moved to the home of Ed Thomas, pictured here in 1946. Thomas was line maintainer and night operator. Hellen and Edna Thomas were day operators. The company was dissolved December 15, 1958, and became a part of Southern Bell Telephone and Telegraph Company.

GENERAL STORE LETTERHEAD AND TELEPHONE BILL. In 1895, T. O. Turner advertised through his letterhead that he was a dealer in groceries, hardware, queensware, and confectioneries. County judge J. L. Blakeley received this telephone bill from the Cerulean Springs Telephone Company in 1939. The three-month total amount due, including long-distance calls, was $3.45.

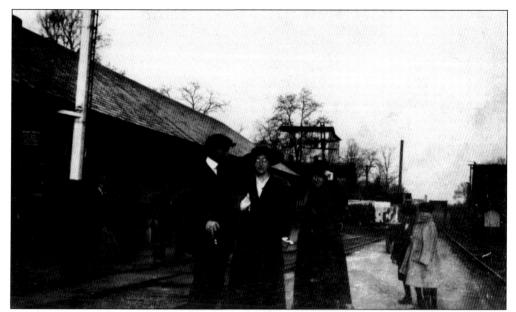

ALL ABOARD. The scene is the Cerulean depot *c.* 1917 with the flour mill in the center background and the water tank at right. Robert Blakeley and his aunt, Woodson Turner, appear to be waiting for a train. Passenger train service ended at Cerulean on December 7, 1941. The track was taken up in 1992.

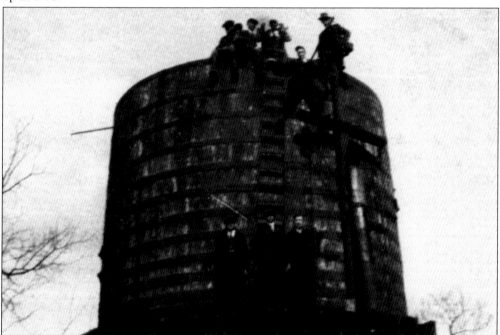

RAILROAD WATER TANK. Steam railroad locomotives required water constantly. Muddy Fork Creek provided the supply for the water tank that was located beside the track near the depot. These young people frequently climbed the structure, as is the case in this 1915 photo opportunity. In the summertime, they went skinny-dipping in the tank, which would often cause the water to foam once it was in the boiler of the engine.

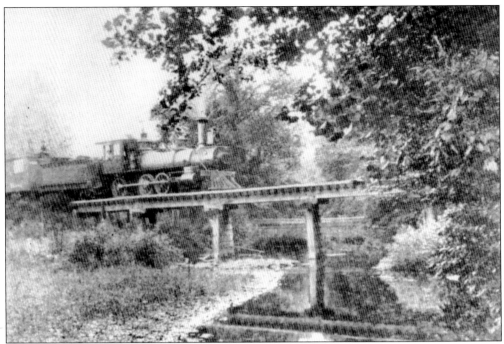

MUDDY FORK TRESTLE. A 4-6-0 Illinois Central Railroad steam locomotive, bound for Cerulean, crosses Muddy Fork Creek over a new wooden trestle. This view, from the late 1880s, represents a new era in social life at the hotel.

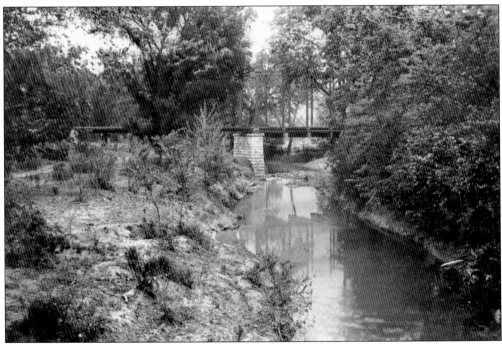

ILLINOIS CENTRAL RAILROAD BRIDGE. This scene, looking upstream on Muddy Fork Creek from the road bridge, shows the iron railroad bridge through the trees. It was constructed around 1900 and was replaced by a concrete structure in December 1954.

Five

CHURCHES AND SCHOOLS

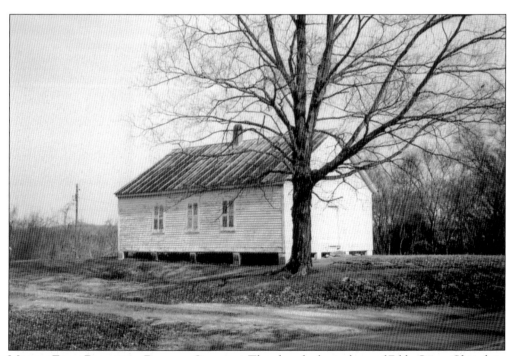

MUDDY FORK PRIMITIVE BAPTIST CHURCH. The church, formed out of Eddy Grove Church in Caldwell County, was organized on March 8, 1806. A log church was constructed on land donated by Jesse Goodwin and was used until the present frame structure was built in 1836. Membership began a steady decline in the 1920s. The church dissolved on October 27, 1956, and the property was later sold to the Cave Spring Baptist Church. It is pictured in 2006.

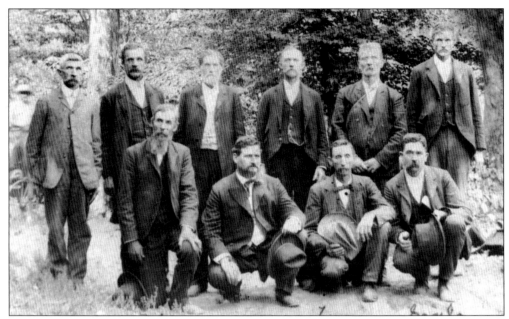

PRIMITIVE BAPTIST PREACHERS. Annual associational meetings of the Primitive Baptist faith brought together the ministers throughout the region. Pictured here c. 1890, from left to right, are the following: (first row) L. Chandler; unidentified; David R. Turner, Cerulean; L. D. Seals, Van Lear, Tennessee; (second row) Joe P. Jenkins; J. R. Hatcher; unidentified; J. L. B. Darnall, Linton, Kentucky; and two unidentified.

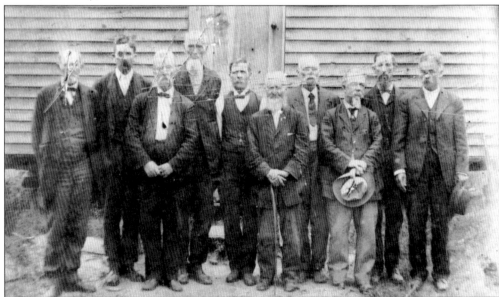

LATER GATHERING OF PREACHERS. Another group of Primitive Baptist preachers was probably photographed at the Muddy Fork Church in Cerulean. Pictured, from left to right, are J. M. Perkins, Mayfield, Kentucky; L. D. Seals, Van Lear, Tennessee; J. L. B. Darnall, Linton, Kentucky; Ben D. Clark, Providence, Kentucky; C. K. Haynes, Mayfield, Kentucky; Wilford Morgan, Princeton, Kentucky; unidentified; Dr. Heidt, Nashville, Tennessee; David R. Turner, Cerulean; and W. B. Overby, Benton, Kentucky.

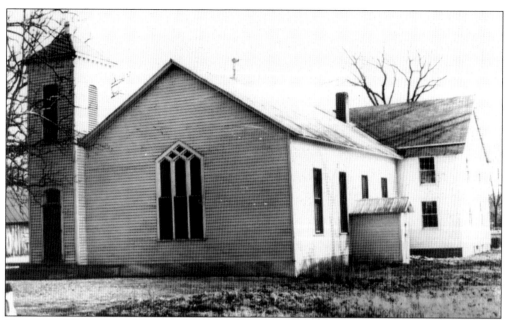

CERULEAN MISSIONARY BAPTIST CHURCH. Cerulean Missionary Baptist Church, pictured here in 1952, was organized in 1858 with 40 charter members. In 1860, the first church, with a slave balcony, was built. It was destroyed by fire in 1867. The present sanctuary, built in 1903–1904, was dedicated on June 25, 1905. A two-story annex was added in 1951–1952. The sanctuary was remodeled in 1954, when the corner tower was removed and was replaced by a steeple.

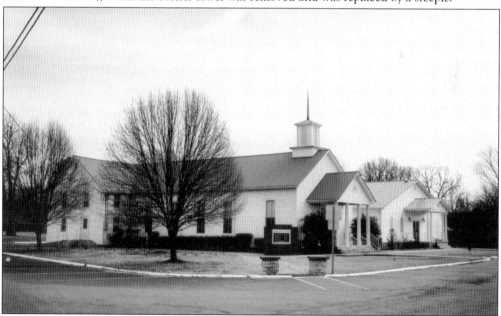

CERULEAN MISSIONARY BAPTIST CHURCH. In 1888, about 26 members were granted letters to organize the Buffalo Lick Baptist Church. In 1892, the church was used for school exercises and a political rally. In 1922, carbide lights were installed. The educational building, consisting of nine classrooms, was built in 1951 at a cost of $9,000. In July 2001, the fellowship hall (at right) was dedicated.

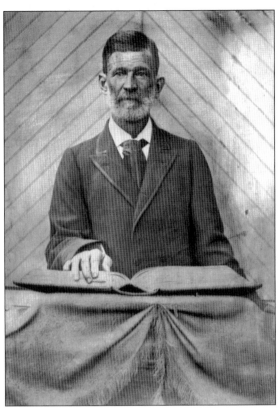

REV. ED LADD. Rev. Ed Ladd (1849–1907) served as minister of Cave Spring Baptist Church from 1901 to 1907. During his ministry, the congregation moved from Cave Spring and built their first church in Cerulean. Born a slave, Ladd was freed after the Civil War. He and his wife, Gotha, had six known children: Lucy, James, Jesse, Udolph, Paul, and Dock.

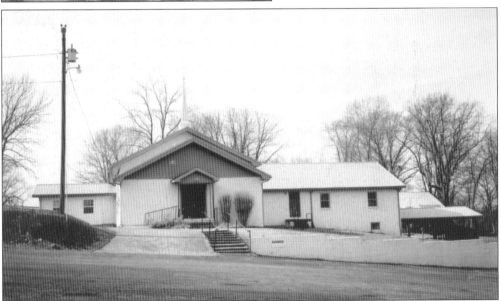

CAVE SPRING BAPTIST CHURCH. African American residents of the community organized the Cave Spring Baptist Church in 1882. The spring, located on Highway 124, was 0.9 miles inside Christian County, 3.5 miles from Cerulean Springs. The church was later moved to Cerulean and located behind the Muddy Fork Primitive Baptist Church. The present church, photographed in 2006, was erected in 1952 under the leadership of Rev. H. E. Dillard, the first full-time minister.

REV. SHALMON RADFORD. The current minister of Cave Spring Baptist Church, Shalmon Radford, is a native of Trigg County and was born in 1978 to Fred and Portia Mann. A graduate of Trigg County High School in 1996, he has been minister of the church at Cerulean for nine years. He married Roshun Merriweather and they have two children, Sean and Jada. Reverend Radford is currently a student at the American Baptist College in Nashville, Tennessee.

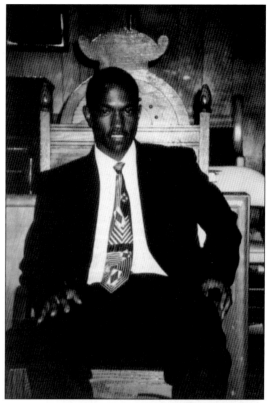

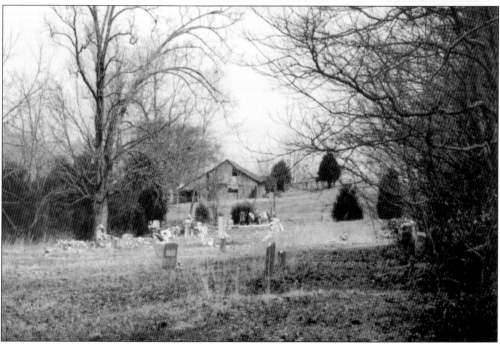

CAVE SPRING CHURCH CEMETERY. This burial ground for Cerulean's African Americans was established over a century ago. Many honored and revered people are buried here.

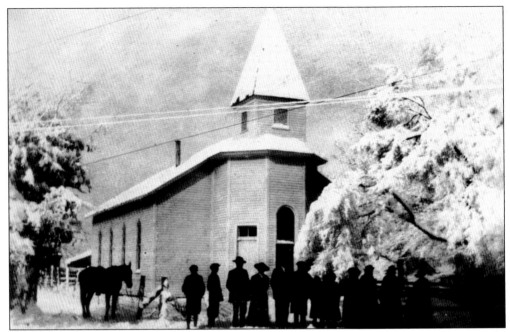

CERULEAN METHODIST CHURCH. The church, originally named Cave Spring Methodist Church, was organized at Cave Spring in Christian County in the early 1890s. Cave Spring is located about two miles north of Cerulean on Highway 124. Church members moved their services to Cerulean about 1900 and constructed the Cerulean Methodist Church on the northwest corner of Main and Hopkinsville Streets. It was destroyed by fire on March 22, 1966. It is seen here around 1918.

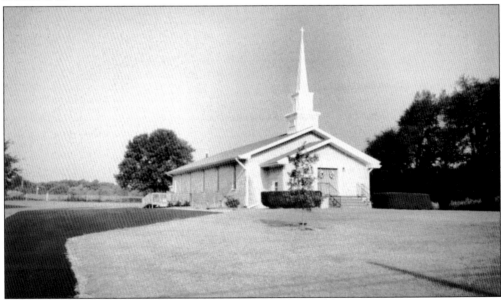

CERULEAN UNITED METHODIST CHURCH. When the fire destroyed the old church in March 1966, services were held in the Cerulean Masonic Lodge. The small congregation faced indecision about rebuilding, but with the leadership of Dabney Rascoe, they took on the task. The first service was held in the new church on January 1, 1967.

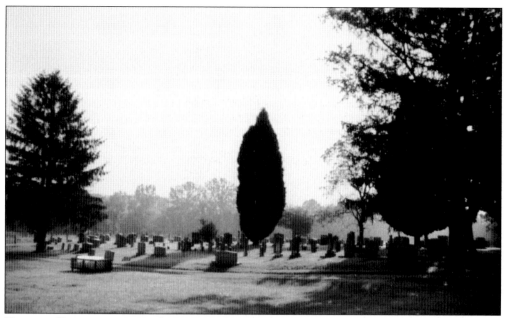

TURNER GRAVEYARD AND CERULEAN CEMETERY. In October 1861, Turner Graveyard was established by Squire Robert "Bob" Rogers and his wife, Leah Goodwin Turner. Upon the death and burial of their son, Robert Payton "Pate" Turner, the couple gave the land for a graveyard to bury family members and their connections. Pate died in the Christian Church C.S.A. Hospital in Hopkinsville. Cerulean Cemetery, adjoining the Turner Graveyard, was established in 1920 and is photographed in 2006.

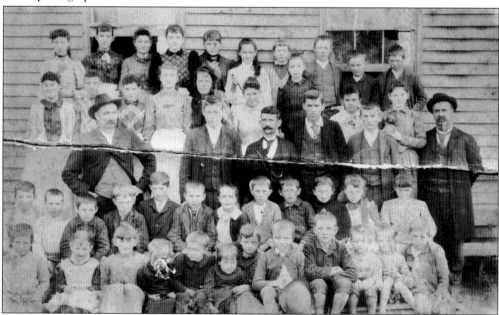

CERULEAN SPRINGS SCHOOL. A group of Cerulean students and teachers appear in the earliest known community school photograph. Dating from about 1890, the only identified person is T. O. "Tom" Turner (third row, fourth from left). The teacher is standing in the middle and the two trustees flank each end of the third row.

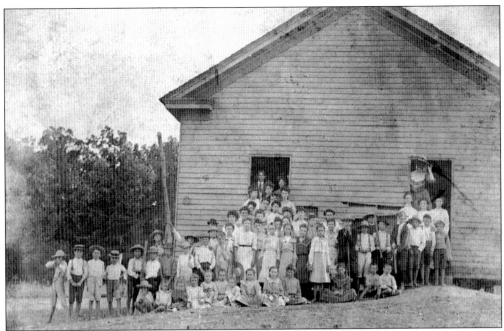

CERULEAN SPRINGS SCHOOL. This gathering on a dusty playground of students with straw hats, knee britches, bare feet, and print dresses represents a very special occasion—picture-making day. The students of Cerulean School, about 60 strong, are assembled in front of the old school c. 1902. Wear and tear on the building is obvious.

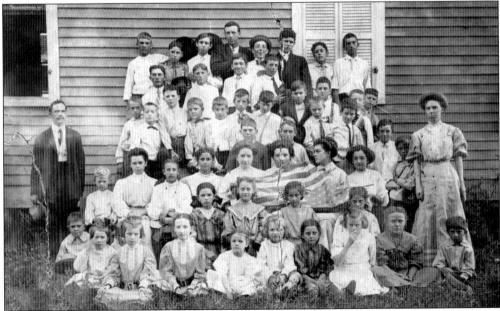

SCHOOL GROUP AT CERULEAN. Nearly 50 students assembled with their teachers for a photograph one spring day in 1908 as the school term was about to end. Teachers were Professor McGowan and Mary Etta Merritt. Mary Jo Wallace, later the mother of Kentucky governor Edward T. "Ned" Breathitt, appears in the second row, third from left. The American flag, though upside down, gives a patriotic flare to the event.

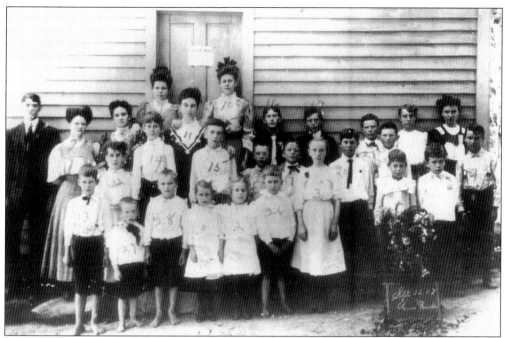

BOW TIES AND BARE FEET. Joe Blakeley School was located near Buie's Knob, about two miles east of Cerulean. It opened in 1906 and operated through 1918, when it consolidated with Cerulean. This neat row-by-row group of scholars gathered to have their likeness struck on September 27, 1907. The teacher was Anna Rawls, who later married J. Minos Turner.

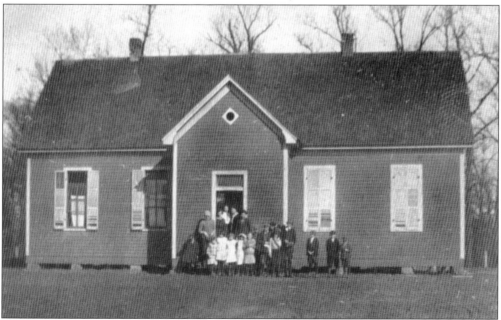

NEW SCHOOL BUILDING. School trustees led the building of three new facilities, all at different locations. This building was the second. Constructed in 1906, it included three classrooms, a vestibule, and cloakrooms, and is pictured in 1908. They were all heated by coal-fired stoves and cooled by opened windows. Outdoor conveniences were located behind the school.

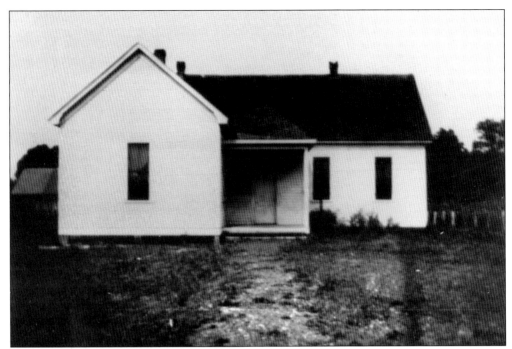

REMODELED CERULEAN SCHOOL. During the era of World War I, a room was added to the front of the 1906 school. The building was used until the new brick school was built in 1928. The first high school graduation was held in 1918 and continued annually through 1936.

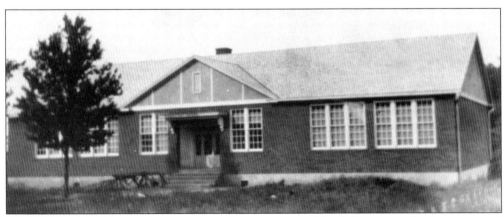

THE PRIDE OF CERULEAN. A community subscription raised funds for a new school, constructed in 1928. Deeded to the Trigg County School Board, the facility then provided for grades 1 through 12. The high school was the last to be consolidated into the Trigg County School system, which was done in 1937. Cerulean School continued grades one through eight until it closed in 1963. The building was demolished in 1964.

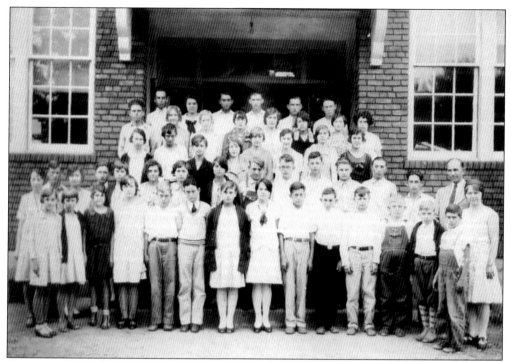

CERULEAN HIGH SCHOOL. Pictured here in 1930, the entire high school class of Cerulean School gathered on the front steps for this photograph.

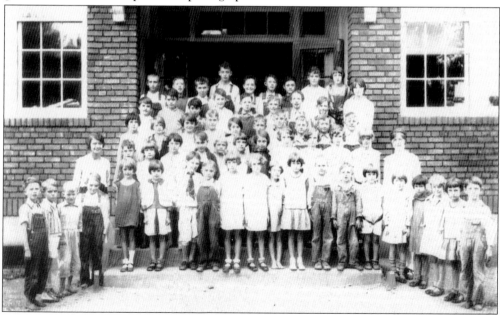

CERULEAN GRADE SCHOOL. Cerulean Grade and High School, located on the Hopkinsville Road, provided for grades 1 through 12 until 1937, when the high school was moved to Cadiz. The structure was in use for grades one through eight until the school closed in 1963. It was torn down the next year by Garnett Lancaster. Brick from the school was used in the construction of two homes, one in Cerulean and the other in Pembroke.

EIGHTH GRADE GRADUATES. Pictured here in 1931, from left to right, are Garland Stewart, Helen Wood, Glen Wood, E. F. Goodwin, Nettie Lewis Turner, Hubert Stewart, and Furmon Brashears.

OUT IN THE SNOW. Pictured here, from left to right, are the following: (first row) Tommy Campbell, Janette Mitchell, Joyce Burgess, and Leroy Pollard; (second row) two unidentified, Edward Orten, unidentified, and Shelby Roberts.

Six

OTHER SPRINGS OF WESTERN KENTUCKY

BLUFF SPRING, CHRISTIAN COUNTY. Bluff Spring is located at the foot of a bluff about 3 miles from Lacy School and 14 miles from Hopkinsville. This freshwater spring motivated Capt. James Robinson to move nearby when he settled after the Revolutionary War. The spring is now piped out of the base of a limestone bluff, at the top of which are the imprints of turkey tracks and a man's hand.

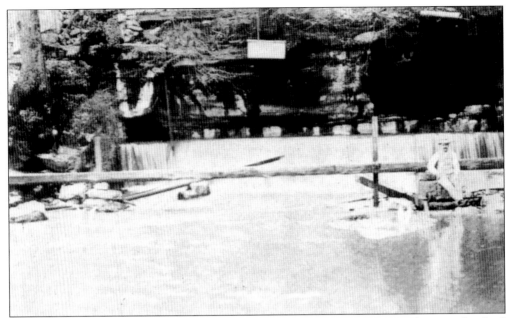

BIG SPRING, CALDWELL COUNTY. In 1797, Capt. William Prince (1752–1810) received a deed for a tract of land that surrounded Big Spring at the head of Eddy Creek. Several animal and Native American trails converged at this point, and here Captain Prince built a two-story limestone structure to serve as both a home and a tavern. He called the place Shandy Hall, and the community was originally called Eddy Grove.

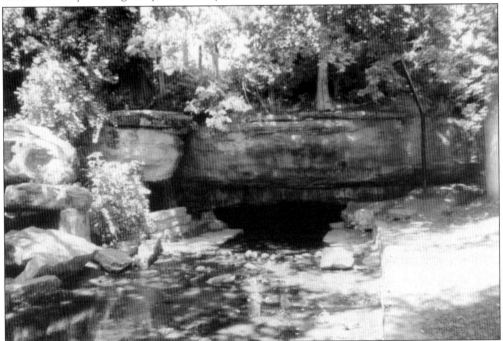

BIG SPRING, CALDWELL COUNTY. Pictured here in 2006, the fresh waters of Big Spring continue to pour forth as they did 200 years ago. Though not a watering hole today, the tree-shaded area offers relaxation in the 21st century.

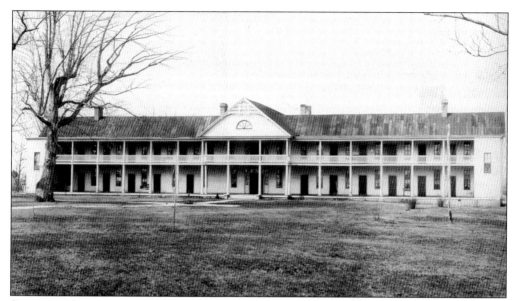

SALUBRIA SPRINGS, CHRISTIAN COUNTY. Salubria Springs Hotel is pictured here in 1933. Located near Pembroke in the old community of Salubria Springs, which dates from the 1830s, this 40-room health resort hotel opened June 20, 1908. It operated for some 20 years prior to its conversion into the Christian County Benevolent Home, which was in operation from 1933 until 1958. A nursing home occupied the building into the 1960s, and later Robert Proctor used the structure for storing building material.

SALUBRIA SPRINGS BAND. The community of Salubria Springs sported its own band for entertainment throughout the area. This 1869 tin-type view featured Rhoden Hoard, John Hanna, Dave Hoard, Taylor Rawlings, Buck McRae, James McRae, Meck Lackey, John Penick, Lem Rawlins, Harry Hoard, and Douglas Lander. Others are unidentified.

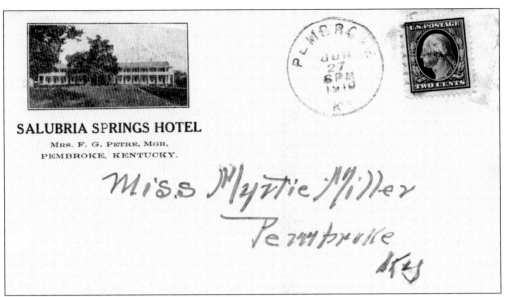

SALUBRIA SPRINGS HOTEL

MRS. F. G. PETRE, MGR.

PEMBROKE, KENTUCKY.

Miss Myrtie Miller

Pembroke

Ky

A LETTER TO PEMBROKE. On June 27, 1910, an unidentified person addressed a letter to Myrtie Miller of Pembroke, Kentucky, from the Salubria Springs Hotel. This letterhead, the only one of its kind known to exist, features a picture of the hotel.

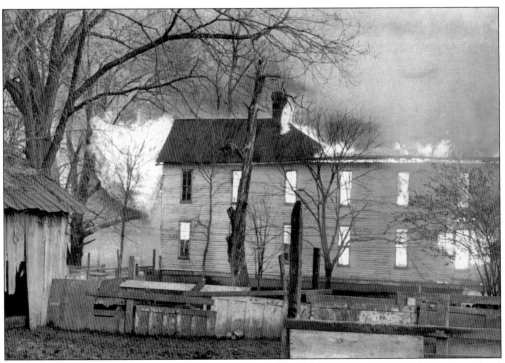

SALUBRIA SPRINGS FIRE. On a cold afternoon, December 17, 1976, the old Salubria Springs Hotel was destroyed by fire. Note the use of hotel-room doors to form pigpens in its latter days. The springs, located between the hotel and U.S. Highway 41, were covered and leveled by bulldozer work many years ago. Because of these events, only photographs and memories remain.

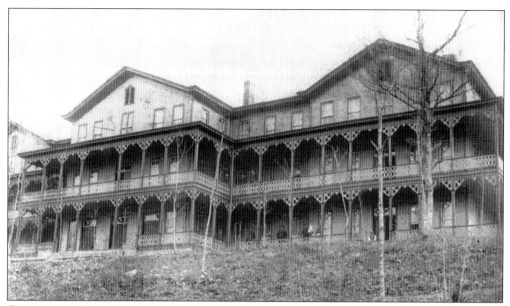

CRITTENDEN SPRINGS HOTEL, CRITTENDEN COUNTY. Located on Hurricane Creek about five miles northwest of Marion stood the majestic Crittenden Springs Hotel, a 125-room, three-story structure built in 1887 by the Crittenden Sulphur Springs Company. The resort, pictured in 1909, flourished until 1910, when nearby mining operations caused the spring water to disappear. In 1919, the hotel was closed, torn down, and a private home was built with the hotel lumber on the site.

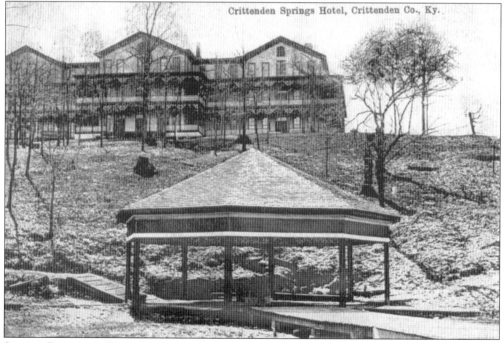

SPRING PAVILION, CRITTENDEN SPRINGS HOTEL. Though the spring pavilion and the hotel, pictured in 1909, are a treasured memory, the remains of the sulphur spring remind occasional visitors of relaxing days when mineral water was the medicinal prescription of the day.

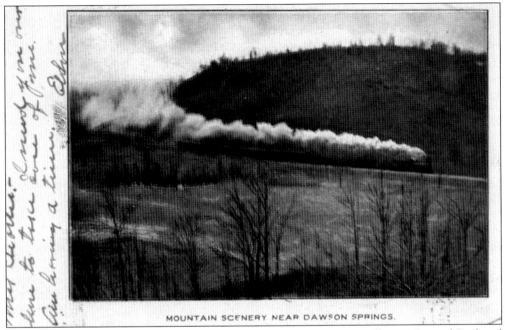

MOUNTAIN SCENERY NEAR DAWSON SPRINGS.

DAWSON SPRINGS, HOPKINS COUNTY. This 1900 scene features an Illinois Central Railroad steam passenger train bound for Dawson Springs. The railroad put this health resort on the map when it was constructed in 1872. First called Tradewater Station, it became known as Dawson by 1874. Dawson City was incorporated in 1882, and the resort was renamed Dawson Springs in 1898. In one year, the railroad sold 50,000 tickets to passengers traveling to this health spa.

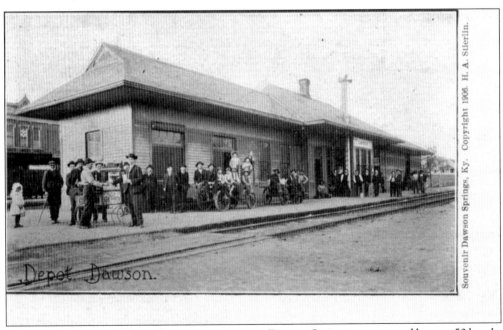

RAILROAD VIEW INTO TOWN. Passengers arriving in Dawson Springs were greeted by over 50 hotels, bathhouses, and boarding homes. This 1912 card, published by C. E. Wheelock and Company of Peoria, Illinois, features the railroad station and water tank (left) and the four hotels (right).

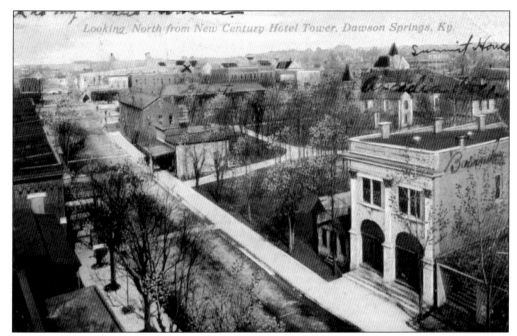

SKYLINE VIEW. In February 1911, Mrs. J. E. Stowe, of Hopkinsville, Kentucky, received this Wheelock card from a friend. The view, looking north from the New Century Hotel tower, shows downtown Dawson Springs, with notations pointing to the depot, the Summit House, the Arcadia Hotel, and the bank.

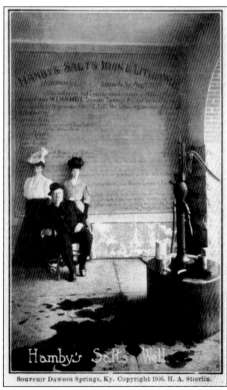

HAMBY'S SALTS WELL. In 1881, W. I. Hamby, "The Father of Dawson Springs," shown here at Hamby's Salts, Iron, and Lithia Well, discovered the first mineral well. In the ensuing years, 40 wells, each with a different mineral content, were successfully dug. These wells supplied health-restoring water to the thousands of visitors who came to "take the waters" and to socialize. As the name of the town implies, the mineral-water sources were wells, not springs.

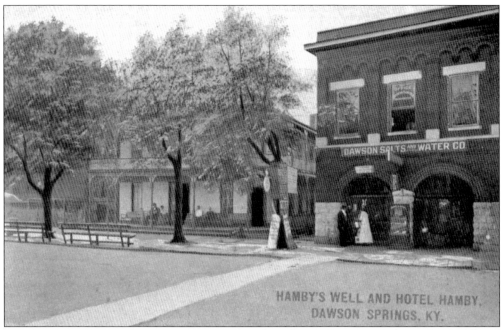

HAMBY'S WELL AND HOTEL HAMBY. In 1911, when this card was mailed, Hamby's Well was located in the building at right and Hotel Hamby was situated at left. W. I. Hamby built this 30-room hotel in 1893. That year, while boring for water to supply his new hotel, Hamby struck an inexhaustible vein of mineral water. This well was also known as the Hamby Salts, Iron, and Lithia Well.

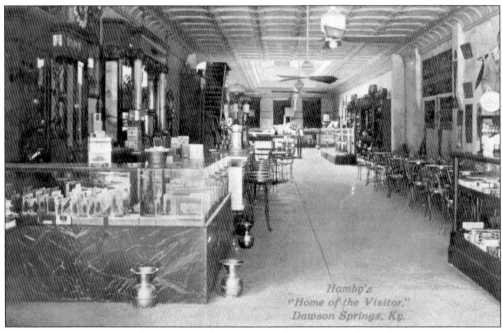

HAMBY'S INTERIOR. Hamby's "Home of the Visitor," the most popular gathering place in town, featured a jewelry, notions, and souvenir shop. A soda fountain was installed on the left, and a dance floor was located in the rear of the building. It is seen here around 1908.

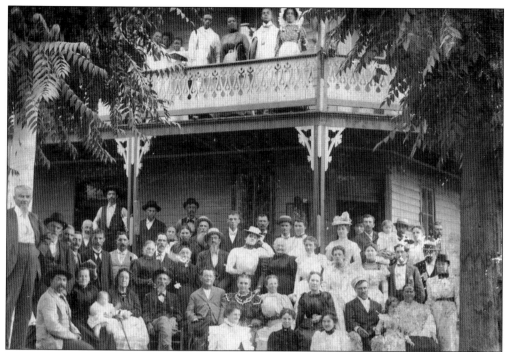

WATER BOARDERS AT THE HAMBY. The Hamby Hotel, featured here in this 1890s photograph, was one of over 50 hotels and boarding houses, all located within a two-block radius in downtown Dawson Springs. The boarders, all dressed in their finery, pose as the African American hotel staff look on from the second-story porch.

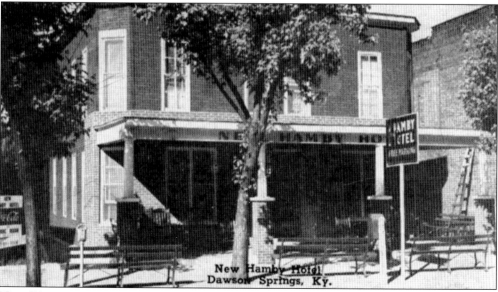

NEW HAMBY HOTEL. W. I. Hamby, Christian County native and Confederate cavalryman, became the most prominent promoter of Dawson Springs mineral water. His enterprises included the development of the Hamby wells, the hotel that bore his name, and the Dawson Springs Water Company. Hamby enlarged the hotel to 50 rooms, as pictured in 1950, and it later became a nursing home before being torn down in 1964.

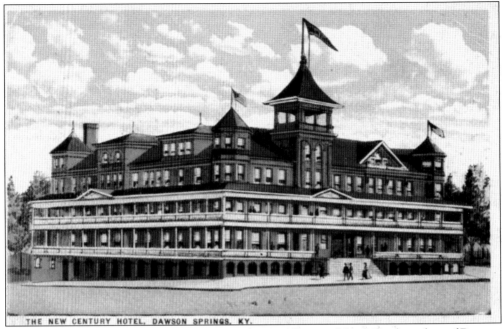

THE NEW CENTURY HOTEL, DAWSON SPRINGS, KY.

NEW CENTURY HOTEL. Pictured here in 1907, the New Century Hotel, the showplace of Dawson Springs, was designed by A. L. Lassiter of Paducah, Kentucky, and was constructed in 1902 by Forbes and Brothers of Hopkinsville, Kentucky. It contained 150 rooms and 75 bathrooms. Upper and lower porches, each 268 feet long, provided extensive space for sitters and promenaders. In later years, the upper porch was removed along with the tower roof.

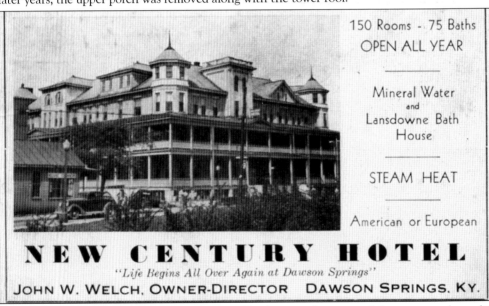

150 Rooms - 75 Baths
OPEN ALL YEAR

Mineral Water
and
Lansdowne Bath
House

STEAM HEAT

American or European

NEW CENTURY HOTEL
"Life Begins All Over Again at Dawson Springs"
JOHN W. WELCH, OWNER-DIRECTOR DAWSON SPRINGS. KY.

NEW CENTURY HOTEL. By 1935, New Century Hotel postcards presented the structure dressed in its white stucco finish. The main floor included a handsome lobby with a grand staircase leading to the upper floors. An elegant dining room, where delicious meals served with mugs of the rusty red mineral water were provided, and the 47-by-60-foot ballroom, where orchestra music greeted the throngs of dancers, were the hotel's hallmarks.

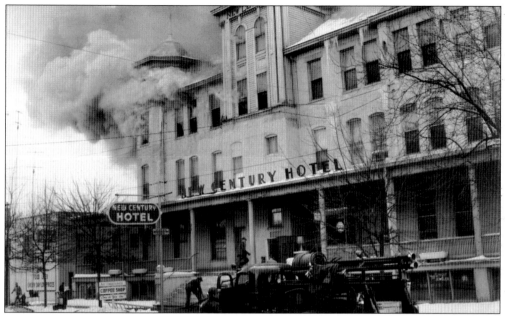

DEATH OF A GRAND OLD LADY. On Sunday afternoon, March 6, 1960, fire destroyed the pride of Dawson Springs. The blaze, possibly caused by defective wiring, was discovered in a west-wing basement room about 11:15 a.m., and within four hours, the New Century hotel was gone. The only vestiges of this grand old lady are photographs, postcards, water mugs, jugs, and bottles.

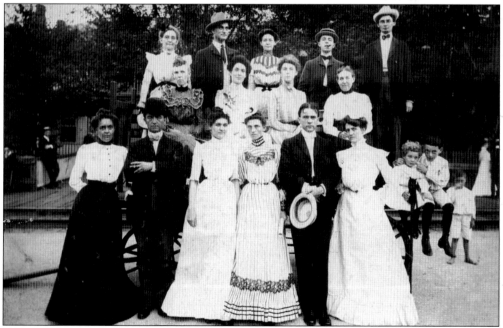

IN BEST BIB AND TUCKER. Pictured in 1900, from left to right, this Hopkinsville group includes the following: (first row) Suzie Stites, Howell Tandy, Mary Flack Tandy, Fan Underwood, John Bullard, Mary Bullard, and children Tom R. Underwood and Monroe Samuels; (second row) Mary Byars, Lucy Summers, and two unidentified; (third row) unidentified, Jake Daniels, Jane Daniels, Fritz Fallenstein, and Thomas C. Underwood.

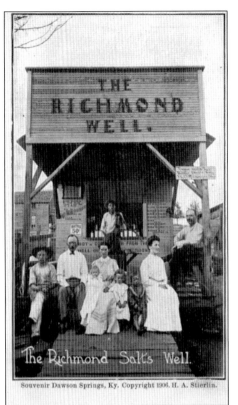

THE RICHMOND WELL. W. D. Richmond and J. E. Hayes established the Richmond Well when, while boring for water supply, they struck the Richmond well vein. Mineral water from the well was sold, both hot and cold, to summer visitors. It later became known as Doom's Well. In this photograph, Mr. and Mrs. Richmond are seated on the porch, and John Bridges is standing behind the pump.

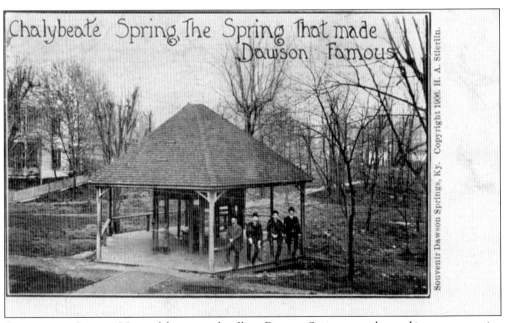

CHALYBEATE SPRING. Many of the mineral wells in Dawson Springs were located in very attractive pavilions, making them convenient to public use. Dippers were handy, as people sampled and compared the various mineral waters.

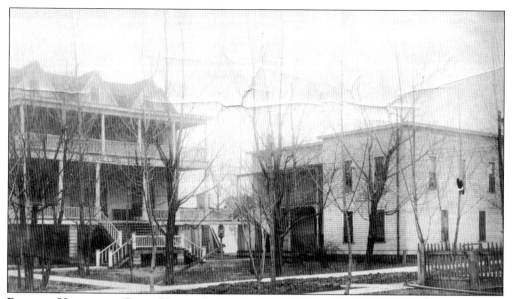

PHILLIPS HOTEL AND BATH HOUSE. In August 1918, Jeannette Draper of LaFayette, Kentucky, received this card from a pal in Dawson Springs. The Phillips Hotel and Bath House advertised cool rooms, a shady lawn, mineral water baths, and a total of seven wells on the property, which was located on Poplar Street. This 40-room hotel, owned and operated by Mr. and Mrs. J. R. Phillips, opened July 15, 1910, and burned July 25, 1932.

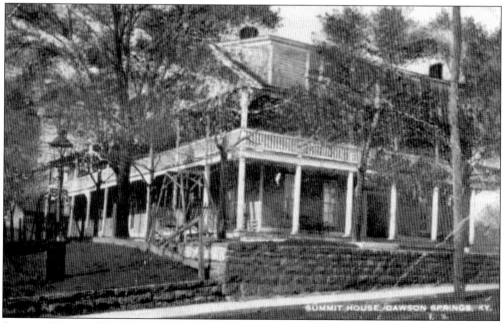

SUMMIT HOUSE. The Summit House, located on Railroad Avenue, was built in 1892 by H. H. Ramsey of Henry County, Tennessee. It operated for a time after 1900.

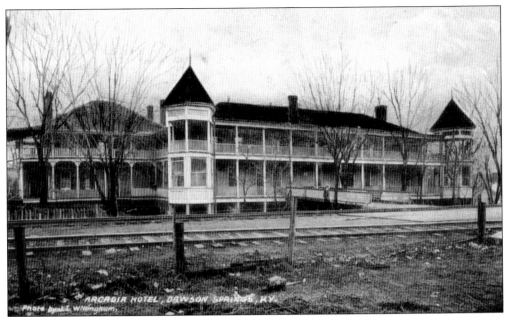

ARCADIA HOTEL. The Arcadia Hotel, the first of the resort hotels of Dawson Springs, was built in 1882 and was located on North Railroad Avenue in a densely shaded park. J. W. Pritchett, N. M. Holeman, and Lee O. Dixon were the owners and operators until it closed about 1923. Entertainment included a ballroom with an orchestra and four small parks, each with a mineral well. It is pictured around 1900.

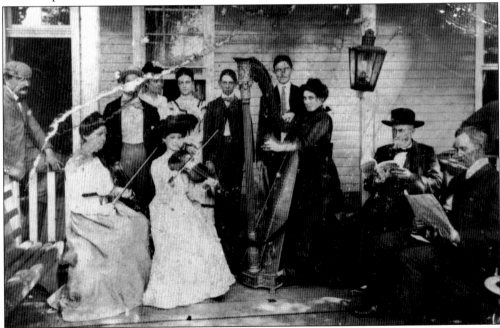

MUSICIANS AT ARCADIA HOTEL. One of the great entertaining events at Dawson Springs was the performance of popular and classical music. These young ladies, on the violin and harp, along with the glow from the oil lamps, created an atmosphere of peace, enjoyment, serenity, and love. This posed scene on the hotel's front porch dates from the late 1880s.

STEVENS BOX BALL ALLEY AND MINERAL WATER PLANT — DAWSON SPRINGS, KY.

BOX BALL ALLEY. One of the many novelty attractions for visitors to Dawson Springs was the Box Ball Alley, seen around 1914. The mineral water plant of E. A. Stevens was located in this structure.

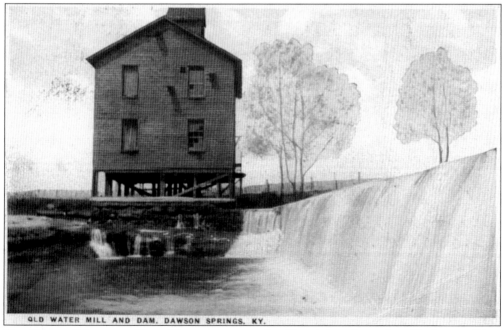

OLD WATER MILL AND DAM, DAWSON SPRINGS, KY.

OLD WATER MILL AND DAM. The water-powered mill and dam, located on Tradewater River at the foot of Cadiz Hill on Highways 672 and 62, was long an attraction for visitors to Dawson Springs. Ray's Mill was in operation there by 1818, and it was variously known as New Market, Price and Lewis, Wilson, White, Bashaw's, and last—into the late 1930s—as Darnell's Mill. This postcard is from around 1910.

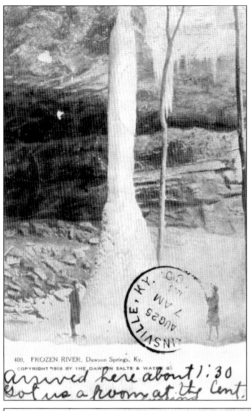

FROZEN RIVER. Visitors to Dawson Springs found many natural attractions, some along the bluffs of Tradewater River and others throughout the countryside. The frozen river at the bluffs is the feature of this card, mailed from Dawson Springs to Hopkinsville in August 1906.

409. FROZEN RIVER, Dawson Springs, Ky.
COPYRIGHT 1906 BY THE DAWSON SALTS & WATER CO.

FISHING IN THREE COUNTIES. A novelty attraction for the visitors who ventured out from Dawson Springs is a point on Tradewater River where the counties of Caldwell, Christian, and Hopkins intersect. This Wheelock card illustrates this point in the river, called Horseshoe Bend.

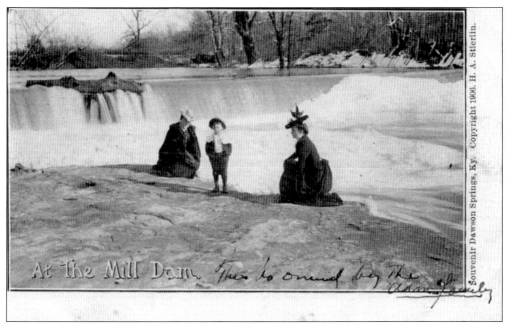

AT THE MILLDAM. H. A. Stierlin produced a number of postcards of Dawson Springs in 1906. One of the scenes featured people at the milldam. The banks provided many ideal sites for picnickers. The waterfall and surrounding scenery made a beautiful backdrop for a lunch in the open air.

WAITING FOR A TURN. A group of young people ready for a ride down Tradewater River gather at a canoe slip in 1912. The multiple layers of clothing and hats must have made for a challenging trip.

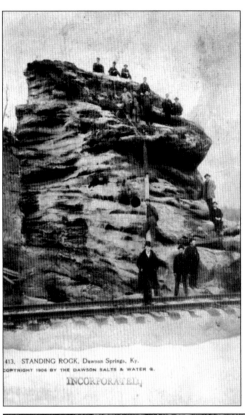

STANDING ROCK. The Elizabethtown and Paducah Railroad was constructed in 1870–1872 in present-day Dawson Springs. The first train to make a trip between its namesake towns, on September 6, 1872, passed through a little settlement then called Tradewater Station. At the west end of this location, the railroad right-of-way made a cut through the terrain, leaving the landmark featured in this c. 1907 postcard.

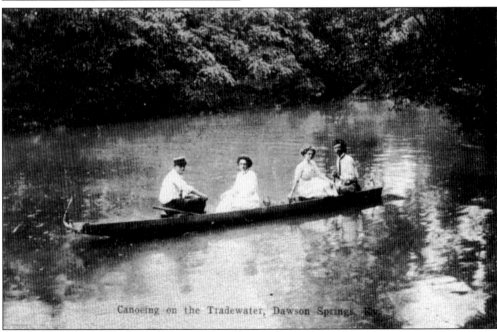

CANOEING ON THE TRADEWATER. In the heyday of Dawson Springs, Tradewater River, then clear of debris, allowed for boating, both canoe and steam powered. Two couples out enjoying a canoe ride are shown in this postcard, mailed in July 1910.

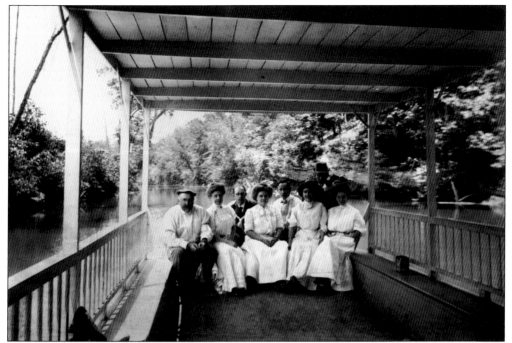

BOAT RIDE. Large, canopied, steam-powered paddleboats with side railings and seats to accommodate 25 to 30 people were popular for excursions. The group appears oblivious to the hot weather and are wearing, as social necessity dictated, long sleeves, corsets, petticoats, and armbands. New Century Hotel manager H. G. Leonard served as host and guide of this trip.

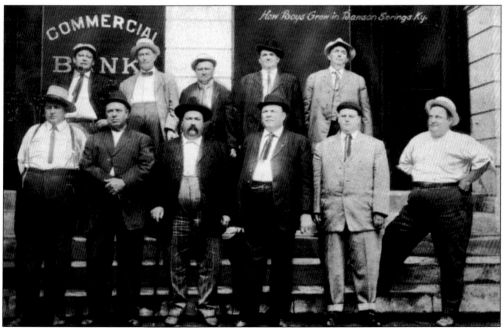

BIG BOYS. Ten men, obviously the movers and shakers of Dawson Springs, appear in a police lineup. Apparently, the mineral water was healthy.

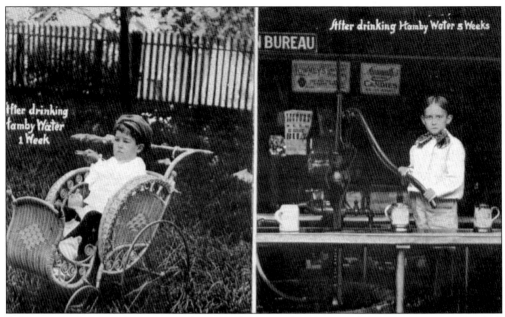

After drinking
Hamby Water
1 Week

BUREAU

After drinking Hamby Water 5 Weeks

A PARENT'S PRAISE. A testimonial postcard appeared in 1908 to heap praises upon Hamby's Dawson Springs Mineral Water. Errol Pierce, a six-year old from Livingston County, Kentucky, was a sufferer of Bright 's disease. He was bloated, crippled, and weighed 60 pounds. After drinking mineral water from Hamby's well for four weeks, the bloat was gone, and he weighed only 34 pounds.

THE CLIFFS. A group of grown people and little folks have probably made a trip down Tradewater River in one of the gasoline or steam-powered flat-bottomed boats, or paddle skiffs, to visit the cliffs. Countless names and dates were carved on the face of Dawson Cliffs. The photographer took this shot on July 20, 1906.

WATERMELON ON THE ROCKS. The beret-bedecked tour guide, New Century Hotel manager H. G. Leonard, joins a group on the rocks as they devour a summer treat around 1910. Hopkinsville attorney W. Herman Southall (extreme right) seems to be enjoying the event. The rock bluff remains today.

A COUPLES OUTING. Ground-length skirts, a fancy straw hat, and suits and ties were the order of the day a century ago, when people visited Dawson Cliffs. The photography business proved quite successful, as many group photographs made along Tradewater River and the bluffs survive today. This one is c. 1910.

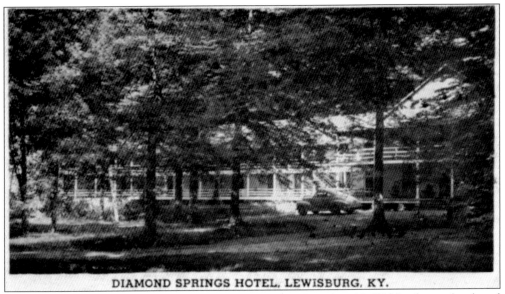

DIAMOND SPRINGS HOTEL, LEWISBURG, KY.

DIAMOND SPRINGS, LOGAN COUNTY. In 1893, James C. Sneed and J. W. Hutchings developed Diamond Springs Iron Water Health Resort. It was located on Rawhide Creek, 14 miles northwest of Russellville and 2 miles from Baugh's Station. This isolated but picturesque rustic resort closed after the 1963 season. It is pictured around 1950.

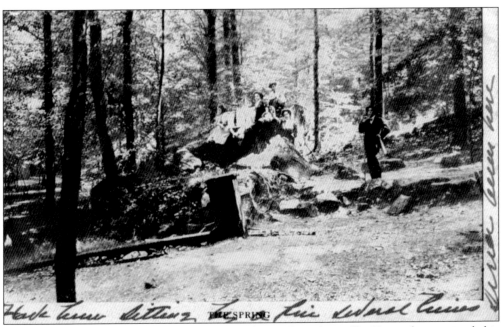

POSTCARD EXCHANGE. In July 1911, Mary Jackson of Hopkinsville, Kentucky, received this card showing Diamond Springs. In the spa era, the exchange of postcards among friends became a popular hobby. Logan County historian May Belle Morton related that, "Tiny quartz rocks sprinkled around the bed of the stream, seemed to glisten like diamonds," thus the name Diamond Springs.

VIEW OF DIAMOND SPRINGS. Mary Smithson of Hopkinsville, Kentucky, received this card from "Saxe" in July 1909. It features the rock bluff, out of which flowed four springs of iron water.

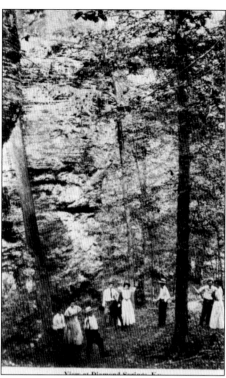

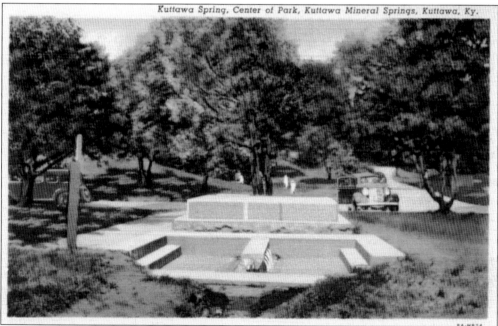

Kuttawa Spring, Center of Park, Kuttawa Mineral Springs, Kuttawa, Ky.

KUTTAWA SPRINGS, LYON COUNTY. Kuttawa Mineral Springs Resort, pictured around 1935, was developed by Charles Anderson around six natural springs. Using the land slope, he created a large swimming hole with continuously changing water. The resort became a popular gathering place about 1880, and by the 1920s, it featured tennis and croquet courts, a barbecue pit, cabins for 200 people, a dining hall, an open-air pavilion, and concession booths.

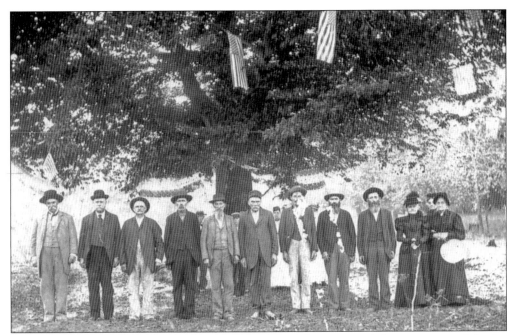

Cobb's Battery at Mineral Springs, Kuttawa, Kentucky. A few survivors of the 1st Kentucky Battery, Cobb's Company, gathered at this spring in 1897 for a reunion of C.S.A. veterans. Pictured from left to right, they are Gen. Hylan Benton Lyon, Lt. Bart James, Cpl. James Dorrah, Pvt. D. G. Dobbins, Pvt. Francis Marion "Frank" Wadlington, unidentified, Pvt. Newton Payne, Pvt. Daniel Black, and Pvt. Daniel Hawley. The ladies featured are unidentified.

Swimming Pool. Kuttawa Resort was very popular for summer band camps. The coauthor, William T. Turner, recalls the 1948 Hopkinsville High School band trip there. This card advertised that the springs would "furnish the most invigorating water you ever tasted."

PETE LIGHT SPRING 5-MILES WEST OF CADIZ, KENTUCKY. ON U.S. ROUTE 68.

PETE LIGHT SPRING, TRIGG COUNTY. Five miles west of Cadiz on U.S. Highway 68, there stood the historic Pete Light Spring Dining Room. Peter "Pete" Thornberg Light (1840–1918), a farmer, built this structure as a home, and his family lived there for many years. In the 1930s, the landmark, pictured around 1948, was converted into a restaurant. With the development of Kentucky Lake, a tourist court (an early name for motels) was added to the business. The dining room burned on August 23, 1999.

Entrance to Roaring Springs Cave near Hopkinsville, Ky.

ROARING SPRINGS, TRIGG COUNTY. Roaring Springs, located near the Fort Campbell military reservation, is a familiar landmark dating from the days of settlement. The name comes from a spring that pours with a loud roar from a limestone cavern about 100 feet below the line of the surrounding country. Old-timers related that after a rain, one could hear the roar of the spring from a considerable distance.

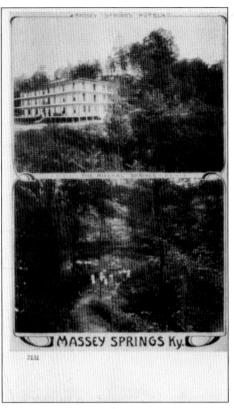

MASSEY SPRINGS Ky.

7131

MASSEY SPRINGS, WARREN COUNTY. The three-story, 40-room hotel was located on the banks of the Green River near Honaker's Ferry, 14 miles north of Bowling Green. The original log hotel, on the bluff above the mineral spring, was built by James Melvin Massey in 1894 and was destroyed by fire. The new hotel was built in 1905 by George F. Cole and a Memphis associate, J. S. Williams. It was torn down in September 1942. This picture is from around 1907.

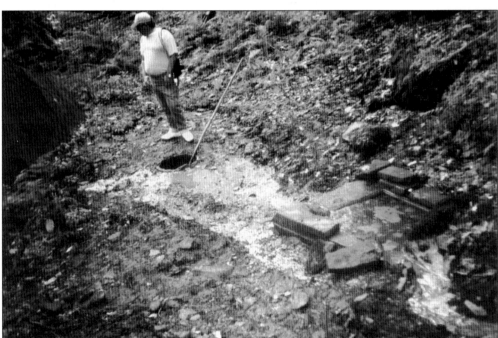

MASSEY SPRING. Iron, alum, and pure water springs flowed from the base of the bluff at Massey Springs. This picture, made in 2002, shows the remains.

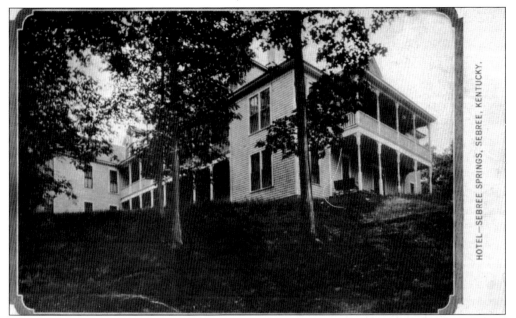

SEBREE SPRINGS, WEBSTER COUNTY. Sometime between 1867 and 1870, Col. Elijah G. Sebree constructed the Henderson and Nashville Railroad through McElroy's Gap. With the discovery of mineral springs, a new town named Springdale was laid out. In 1884, William G. Rork became proprietor of the Sebree Springs Hotel; the date of its establishment is unknown to the authors. It is pictured around 1907.

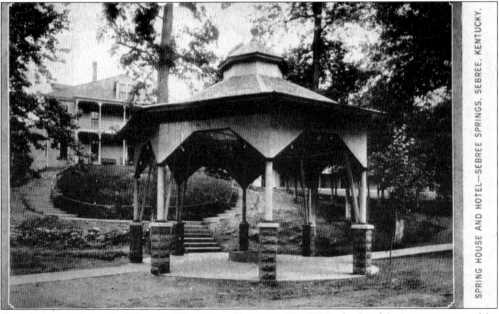

CHALYBEATE SPRINGS HOTEL, WEBSTER COUNTY. By 1896, the health resort, operated by George L. Dial, was known briefly as the Chalybeate Springs Hotel. The spring, located a half mile south of town, poured forth from a seven-foot-deep pit. The water was bottled in crated glass jugs and shipped to customers by railroad. Railroad accessibility increased the average daily summer attendance to 100. It is seen around 1907.

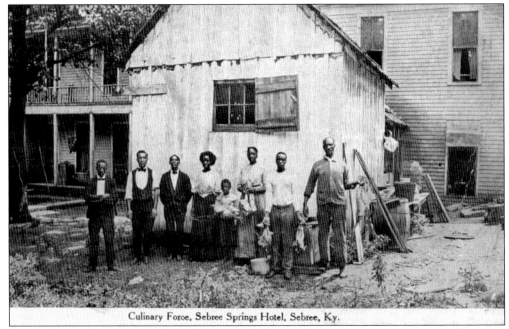

Culinary Force, Sebree Springs Hotel, Sebree, Ky.

CULINARY FORCE, CHALYBEATE SPRINGS HOTEL, WEBSTER COUNTY. A very unusual *c*. 1907 postcard features the culinary force at the Chalybeate Springs Hotel. Black-tie waiters, cooks holding dressed chickens, and a young fellow dispatched with many jobs gives a glimpse of the behind-the-scenes activity that few visitors would witness.

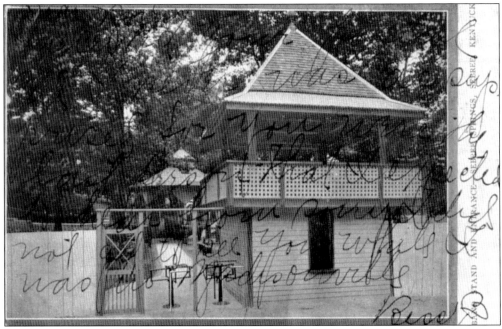

BAND STAND AND ENTRANCE, SEBREE SPRINGS PARK, WEBSTER COUNTY. In 1911, the Sebree Springs Hotel was destroyed by fire. Fraternal orders purchased the grounds and established Sebree Springs Park in 1912. Annual barbecues and social gatherings were held every July 4. Admission to the park was 10¢, and visitors entered through a turnstile. The park is seen around 1907.

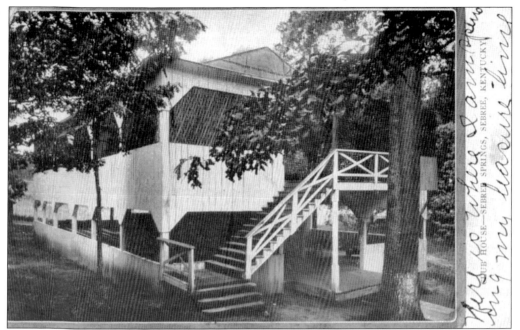

CLUB HOUSE, SEBREE SPRINGS HOTEL, WEBSTER COUNTY. In 1907, John B. Ramsey bought Chalybeate Springs, renaming it Sebree Springs in honor of the nearby town. Ramsey built a large, two-story pavilion, of which the upper floor was used for dancing and the lower level used for vendors and sporting activities, such as bowling.

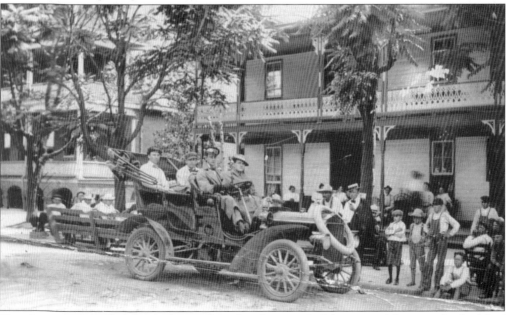

THE ASSASSIN. Little did onlookers realize what the arrival of the automobile meant for the life of mineral spring resorts. This scene in 1906 shows one of the early cars in Dawson Springs, a 1906 Buick Model F touring car. The automobile and the creation of highways ultimately ended the cultural tradition of visiting mineral springs by the mid-20th century, as modern transportation allowed people to travel anywhere, anytime, to new and previously unknown locations.

ACROSS AMERICA, PEOPLE ARE DISCOVERING SOMETHING WONDERFUL. *THEIR HERITAGE.*

Arcadia Publishing is the leading local history publisher in the United States. With more than 3,000 titles in print and hundreds of new titles released every year, Arcadia has extensive specialized experience chronicling the history of communities and celebrating America's hidden stories, bringing to life the people, places, and events from the past. To discover the history of other communities across the nation, please visit:

www.arcadiapublishing.com

Customized search tools allow you to find regional history books about the town where you grew up, the cities where your friends and family live, the town where your parents met, or even that retirement spot you've been dreaming about.